PEGASUS
Library

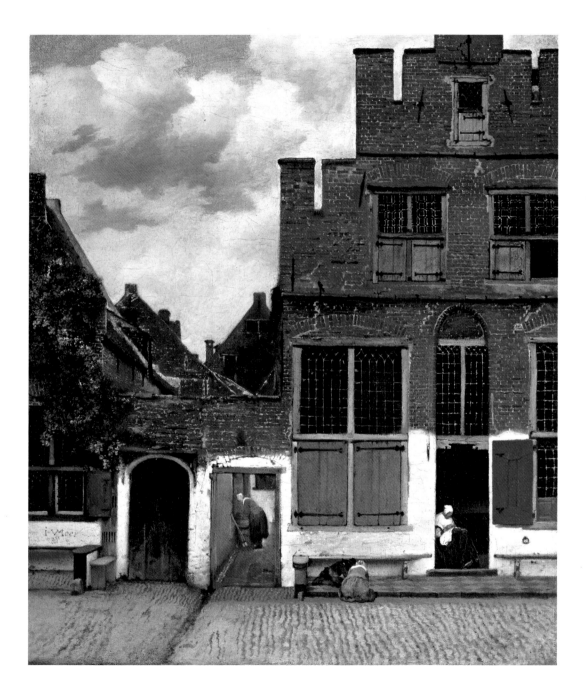

Irene Netta

Vermeer's World

An Artist and his Town

Prestel

Munich · Berlin · London · New York

For my parents, Konrad and Gesa Federlin

CONTENTS

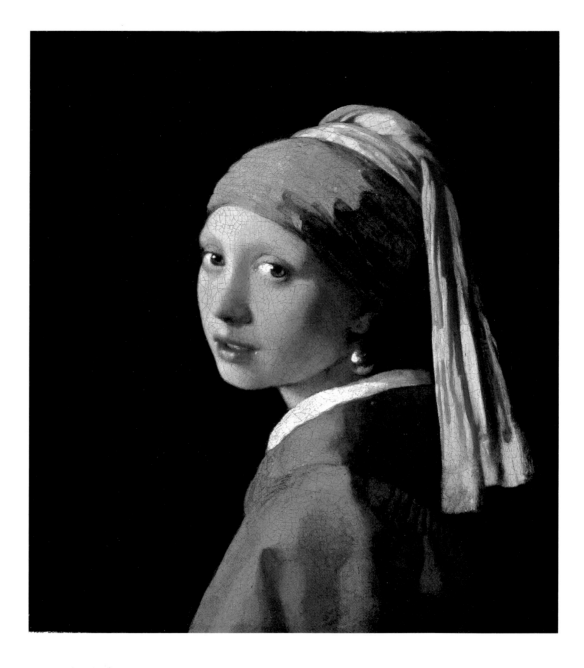

The Pearl Earring

The Myth surrounding
the Artist

Anecdote and conjecture still surround the life of Johannes Vermeer; indeed the sketchy details of his biography have earned him the sobriquet 'Vermeer the Secretive'.[1] In an attempt to make the artist's life in seventeenth-century Delft more tangible for us today, imaginative stories have been written that combine scant, historically-attested details with fictional tales in which characters from the artist's paintings are brought to life and speak on his behalf.[2] It is uncertain, however, just how much Vermeer's paintings actually reflect his own world.

Vermeer's few surviving paintings hardly tell us anything about his life, his personality or his artistic development. In all, only thirty-five paintings have been ascribed to him today. Although evidence shows that he painted more works, his artistic output can be described as modest when compared with that of his contemporaries. It may be supposed that he painted some forty-five to sixty paintings between 1653 and 1675, in other words just two or three a year.[3] Drawings, studies, letters or other personal documents in his hand are unknown. Unlike Rembrandt, who produced numerous self-portraits throughout his life, Vermeer had no interest in self-analysis or in examining his identity as an artist. It is, therefore, not just the lack of documentary evidence that has always shrouded Vermeer in silence and an almost eerie

anonymity, but his artistic output itself has done so, too. This air of mystery continues to surround the artist and his art to this day.

Vermeer was born in 1632, the second child and first son of Reynier Jansz. Vos and Digna Baltens and was baptised Joannis in Delft's New Church. For reasons still unknown, his father only started to use Vermeer as the family surname in 1640. A silk worker who produced a high-quality material called caffa, he was also an art dealer who had been registered with the painters' guild in Delft, the Guild of St Luke, since 1631. The inn that he also ran on the town's Voldersgracht doubled as his premises. Having prospered, he was able to buy a large sixteenth-century house in 1641 together with an adjacent inn called 'Mechelen' in the town's main square (see page 67). He continued to deal successfully in paintings from here, too, and on his death in 1652, the business was taken over by Johannes. There are no records of the years between Vermeer's baptism and this point in his life that tell us how long he spent as an apprentice.

The next recorded mention of Vermeer is as a trained artist when he became a member of the Guild of St Luke on 29 December 1653, although it is not known what prompted him to do so or who his teacher was. Vermeer's interest in art may have been stimulated by the many paintings that his father bought and sold and that had probably enabled him to study a number of different artists and artistic traditions, including international ones, while at home. There is certainly no doubt that they developed his eye for art.

It is still unclear whether Vermeer, besides his practical training, received any instruction in art theory or whether he left Delft to study art elsewhere.

In April 1653, Vermeer married Catharina Bolnes, the daughter of a wealthy Catholic patrician family from Delft. As the son of Protestant parents, however, Vermeer had to convert to Catholicism to marry her, a step not taken lightly in Calvinist Holland. Although Catholics were tolerated in Delft, and counted many prominent citizens among their numbers, they were forbidden from holding their services in public. We know nothing about Vermeer's personal views on religion and the church, but it may be assumed that he was not solely motivated by his private beliefs; by converting, he was doing as his mother-in-law wished. Maria Thins was a woman who played an important role in the Vermeers' family life. She helped the young couple out financially several times and also made generous provision for her daughter in her will. These close family and monetary ties with Maria Thins may have been one reason why Vermeer did not leave Delft after his marriage even for a short time. The Vermeers married in the Jesuit community of Schipluy, now Schipluiden, a small village about an hour's walk from Delft that maintained close links with the town's Catholics.

In 1660 Vermeer and Catharina Bolnes, together with Maria Thins, moved into a building on Delft's Oude Langendijk. The Jesuit community, to which Maria Thins felt very close, was also to be found in he same area and Vermeer is known to have had contact with

them (p. 68). Indeed, some of his early pictures like *Saint Praxedes* (p. 34) and *Christ in the House of Mary and Martha* (p. 32) reveal his examination of the Jesuit body of thought. One of his last large-scale works, the *Allegory of Faith* (p. 11) of 1671–74, was a commission from Delft's Jesuit Order. The painting's symbolic attributes suggest complex theological concepts with which Vermeer must have been familiar. Moreover, he named one of his sons after Ignatius, one of the founders in the mid sixteenth century of the Society of Jesus (Jesuites). Vermeer's conversion to Roman Catholicism cannot, therefore, have been wholly against his own will; he would not otherwise have adopted these themes in the way and to the degree he did. What is more, Maria Thins and Vermeer were bound by a mutual interest in art. Through her cousin Jan Geensz. Thins, Maria Thins was distantly related to the renowned Utrecht painter Abraham Bloemaert (1564–1651). She owned a small collection of pictures by members of the Utrecht school that she and her siblings had inherited from their parents and so was familiar with painting. Vermeer knew certain works in her collection and drew on them in his own interior scenes; they are seen as paintings within paintings on the back walls in some of his works.

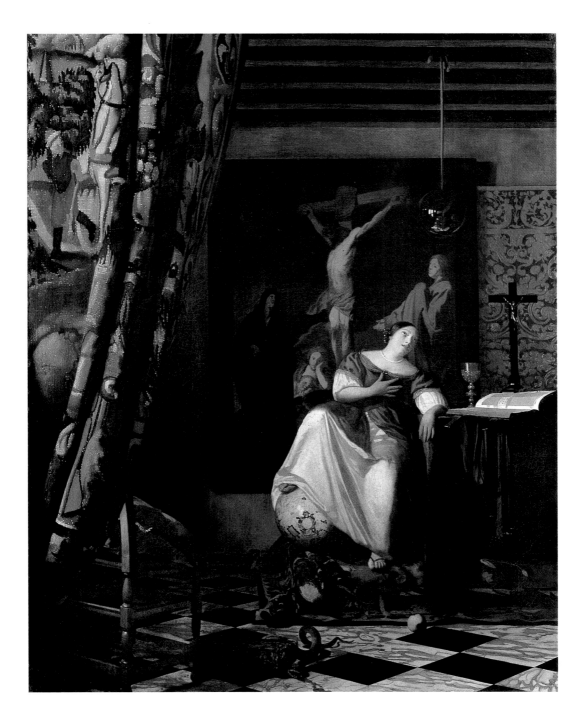

Allegory of Faith

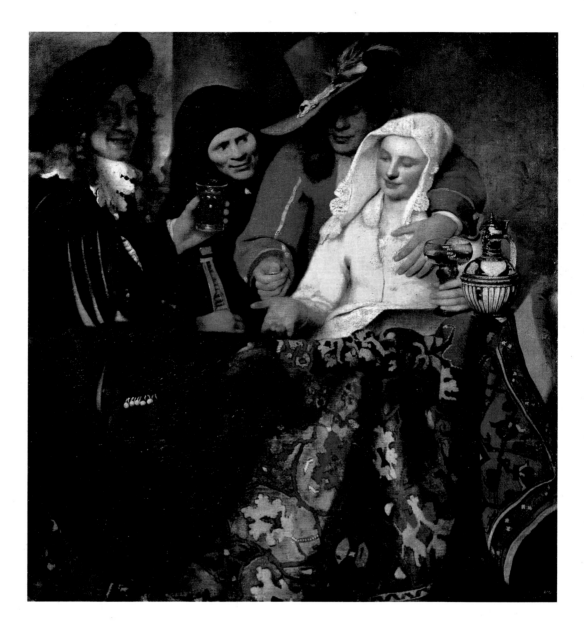

The Procuress

The Procuress by Dirck van Baburen features in two of Vermeer's works, *The Concert* (p. 14) and *Lady Seated at the Virginal* (p. 15). Moreover, Vermeer drew on it for inspiration, both thematically and in terms of its composition, for his early portrayal in 1656 of a brothel scene.

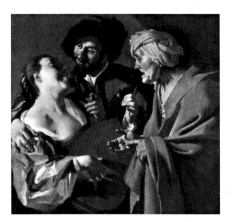

Dirck van Barburen
The Procuress, 1622

On the far right of the painting *The Music Lesson* (p. 16), Vermeer quotes from a *Caritas Romana* that was presumably in his mother-in-law's collection and that belongs stylistically to the circle of Caravaggists at Utrecht; it may even be attributable to the painter Dirck van Barburen or one of his followers.[4] While Vermeer reproduces only half of the *Caritas Romana* (the picture frame bisects it), in another painting, *Woman Holding a Balance* (p. 17), the quotation is strikingly large and almost fills the whole of the rear wall. It is portrayal of the Last Judgement that has given rise to various interpretations of Vermeer's painting, but which has as yet not been attributed to a particular artist.

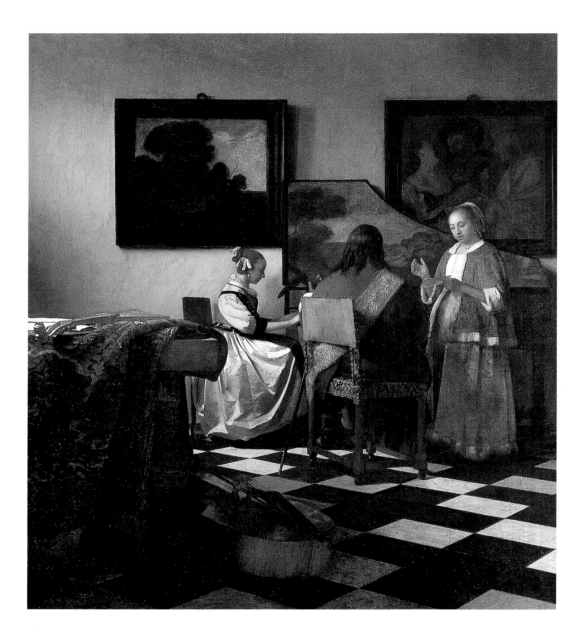

The Concert

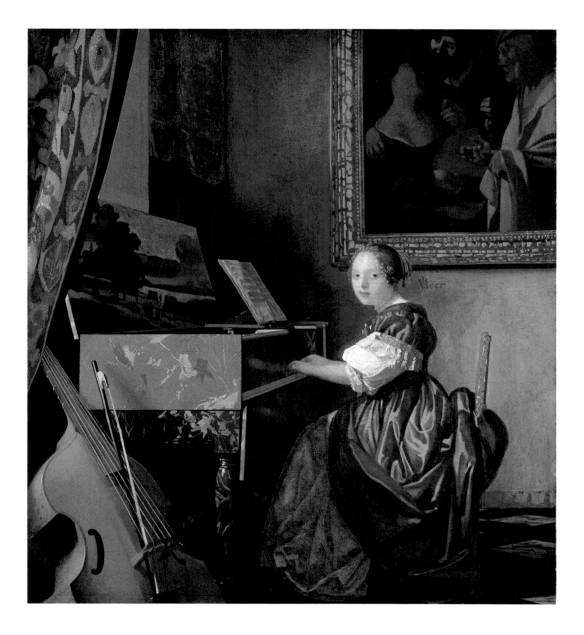

A Lady Seated at the Virginal

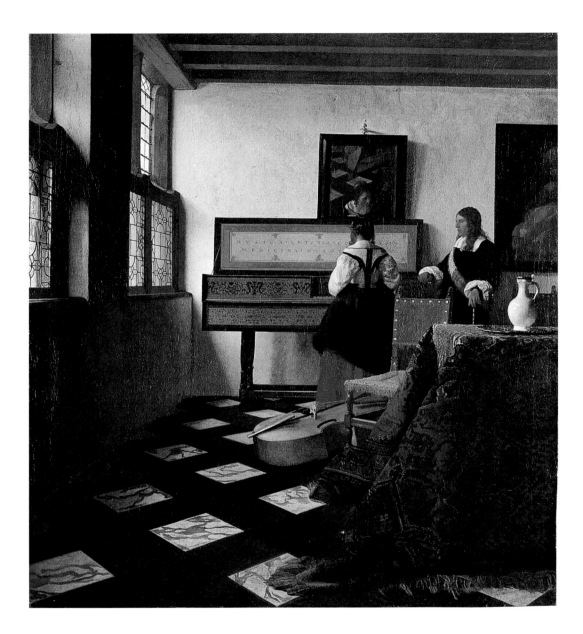

The Music Lesson

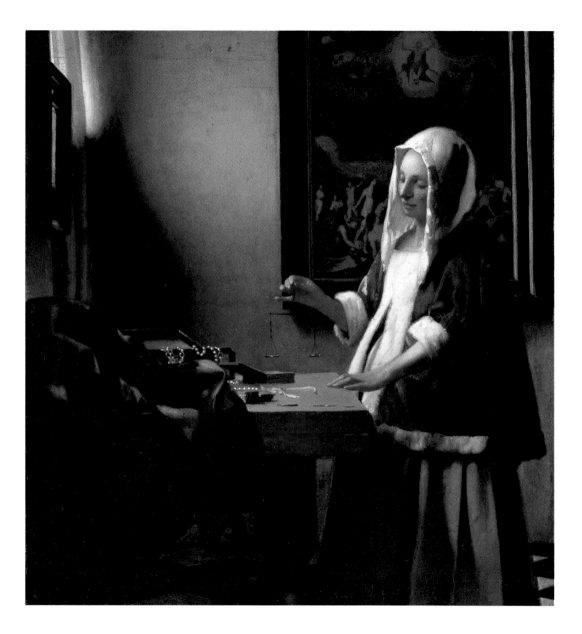

Woman Holding a Balance

Unfortunately there is virtually no concrete evidence linking Vermeer with other painters in Delft or other art centres like Amsterdam, Haarlem, Utrecht or Leiden. We find only two artists' names mentioned in historical documents in connection with Vermeer. Shortly before Vermeer's marriage to Catharina Bolnes in April 1653, Delft's most famous artist at the time, Leonard Bramer (1596–1674), was called upon as a witness.[5] Another document from the same year is signed both by Vermeer and the painter Gerard Terborch (1617–81) who lived mainly in Deventer.[6] The reasons why these two artists were in touch with Vermeer, possibly on a personal level, are not known, however. Beyond that, no other meetings or contacts are known.

Delft had no significant artistic tradition in the first half of the seventeenth century. The town was characteristically aristocratic and conservative, the product of its close ties with the court of Orange-Nassau in nearby The Hague. Vermeer thus found little inspiration in the town's artistic heritage. This changed, however, following the unexpected death of the head of the Dutch Republic, the *stadhouder* Prince William II of Orange, on 6 November 1650, for whom no successor was found (see p. 57f.). There followed a noticeable decline in The Hague's influence on artistic life in Delft which allowed the painters working there, first and foremost among them Johannes Vermeer, greater scope for artistic development. This newly won freedom meant that outside artists again began to show interest in Delft from 1650 onwards. The genre painters Jan Steen (*c.* 1625–79), Pieter de Hooch

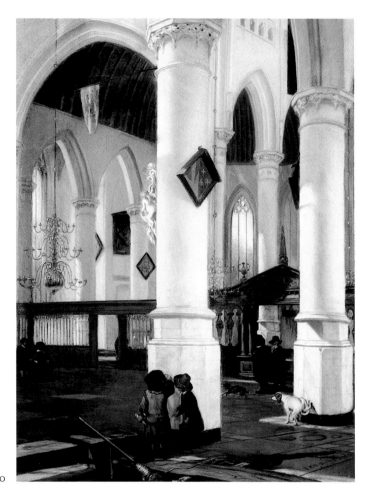

Emanuel de Witte
Interior of the Old Church in Delft, 1650

(1629–84) and Carel Fabritius (1622–54), for instance, worked in the town during the following decade. Their work dealt with themes similar to Vermeer's —mainly interiors and street scenes—and they also seem to have shared similar interests as artists, including the treatment of perspective and investigations into other optical effects. Furthermore, several famous exponents of architectural painting moved to Delft for a time in the 1650s, among them Hendrick van Vliet (*c.* 1612–75), Emanuel de Witte

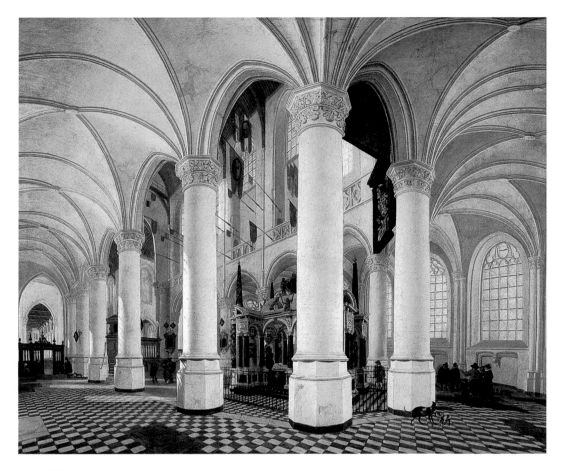

Gerard Houckgeest
*Interior of the New Church with
the Tomb of William the Silent,*
1651

(*c.* 1616–91/92) and Gerard Houckgeest (1600–61).
The latter two painted numerous interiors of Delft's
Old Church (p. 19) and New Church with William I of
Orange's imposing tomb. Although there are now no
records to suggest that connections existed between
these artists, the possibility that they knew each
other cannot be ruled out. Delft was a small town and
it seems improbable that the few artists working there
and registered in the painters' guild did not know
each other well and exchange ideas. At the very least,
it can be assumed that, since around 1650, Vermeer
was able to gain a wealth of impressions and ideas

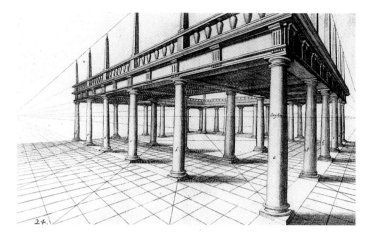

Hans Vredeman de Vries
Drawing no. 24 from *Perspective*,
Leiden 1604

from the works of important artists and to learn from
them even without leaving town.

The dramatic church interiors painted by Houckgeest
and de Witte were based on their intensive study of
the rules of perspective, mainly linear perspective.
The same was also true of de Hooch's interiors. These
artists took their lead from Hans Vredeman de Vries
(1527–before 1609), probably the most influential
theorist in the Low Countries at the beginning of the
seventeenth century. His treatise on perspective in

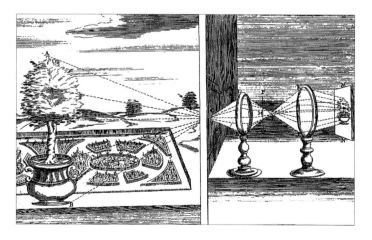

*Schematic Presentation of the Arrange-
ment of Lenses in a Camera Obscura,*
1642

21

Carel Fabritius
A View in Delft, 1652

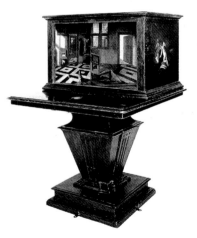

Samuel van Hoogstraten
A Peepshow with Views of the Interior of a Dutch House, c. 1655–60

paintings was published in Leiden in 1604–05 and contained numerous perspectival diagrams giving guidance on how to translate certain three-dimensional views onto the two-dimensional surface of a canvas (p. 21). Additionally, around the middle of the seventeenth century, Delft's artists and scientists alike were busy developing optical instruments such as a wide-angle lens, a viewing box or a portable *camera obscura* (p. 21) that were much simpler to use than the theoretical explanations given in de Vries's treatise on perspective. The optical distortion in Carel Fabritius's *A View in Delft* of 1652 clearly shows that it was based on an experiment in perspective using a wide-angle lens or viewing box.[7]

Known and respected as an artist in his native town, Vermeer was elected head of Delft's Guild of St Luke in 1662–63, aged only 30. It had celebrated its fiftieth anniversary the year before when it decided to retain its conservative statutes in which it defined itself as a

guild for skilled tradesmen. This meant that painting was not classed as a separate artistic activity, but remained on a par with other skilled trades like faience and porcelain manufacture and glass blowing. In other towns like Dordrecht, artists had already broken away from the trades in 1642 and had succeed in establishing their own guilds. Utrecht followed in 1644, Hoorn in 1651, Amsterdam in 1653 and The Hague in 1656. When Vermeer was elected, Delft's painters' guild found itself in an awkward position. Most of its famous members had already left the town and headed to Amsterdam or The Hague.[8] With this position, Vermeer took on some difficult tasks, but despite his young age he was obviously thought capable of solving them.

Vermeer was visited by distinguished art lovers in 1663 and 1669. When the Frenchman Balthasar de Monconys visited Delft in August 1663, he wanted to see Vermeer's work, too, but the artist seems to have had no paintings of his own in his studio at the time. Vermeer was merely able to show him two of his canvases in the possession of a baker, presumably Hendryck van Buyten. The Frenchman noted tersely in his journal that Vermeer's paintings probably had too high a price placed on them. Twice in quick succession in May and June 1669, Pieter Teding van Berckhout (1643–1713), a wealthy young man from The Hague, visited Vermeer in his studio and had more luck. Unlike de Monconys, van Berckhout expressed great admiration in his journal for Vermeer's paintings, mainly because of their unusual and strange perspective. In May 1672, during his second

term as head of the painters' guild, Vermeer, along with another Delft artist, Johannes Jordaens (1616–80), was called to The Hague as an expert witness in a dispute concerning twelve Italian paintings. His opinion as to their authenticity and the value of international art was thus in demand beyond Delft. These historical documents show that Vermeer did not go unrecognized as an artist during his lifetime and that, by 1660 at the latest, his reputation, his art and his judgment were greatly valued not only in his hometown but also further afield, although it is probable that none of his paintings was seen elsewhere. Between 1655 and 1674, he had only one buyer, a Pieter Claesz. van Ruijven (1624–74) and his wife. As members of Delft's upper classes, they had a considerable fortune at their disposal. This meant, of course, that yet again Vermeer's paintings did not leave Delft and that his work could only be seen in the private collection of one family. In the end this must have hindered the dissemination of his art and probably cost him outside commissions. Except for the *Allegory of Faith*, no other commissioned work is known by Vermeer. It is improbable that the paintings acquired by Pieter Claesz. van Ruijven were commissions. The fact that Vermeer did not usually accept commissions and also took a long time to produce his paintings was highly unusual for his day.

When France, under King Louis XIV, invaded the Dutch Republic in 1672, the Dutch economy collapsed, badly affecting Vermeer and his family. He could sell neither his own pictures nor those by other artists that he was trying to market on commission as

an art dealer. When Vermeer died three years later aged 43, his widow was left with at least ten young children to look after and a vast debt.

With few exceptions, Vermeer's paintings were interiors in which one or several persons are shown playing music either alone or in company, sitting with a glass of wine (*The Glass of Wine*, *c.* 1658–60; p. 26) or engaged in a domestic activity (*The Lacemaker*, *c.* 1669–70; p. 27). A total of twenty-five such paintings are acknowledged today as being by Vermeer. There was a long tradition of such genre paintings in Dutch art that the artist could resort to. Similarly, models existed for his two townscape paintings, *The Little Street* (frontispiece) and *View of Delft* (p. 42f.), as well as for the two allegories *The Art of Painting* (p. 36) and *Allegory of Faith* (p. 11). The work of other painters influenced Vermeer time and again, as is shown by the similarities between the subjects of his own interiors and those of Pieter de Hooch or Gerard Terborch, for instance. What makes Vermeer's art special is less its subject matter than the way he translates it into an artistic composition and his innovative treatment of widely used and traditional subjects. What is particularly noticeable is the curious way Vermeer's art seems to be isolated from outside influences, something that characterises almost all of his paintings. The detachment of his works and the peaceful solitude of his interiors are all the more surprising given that more than ten children lived in the artist's home. Everyday life there must have been rather hectic, yet the artist seems to have banished disruption of any kind from the domestic scenes he portrays in his paintings. Even

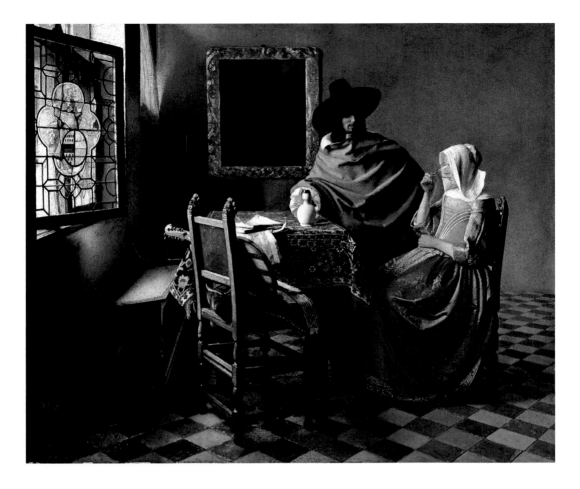

The Glass of Wine

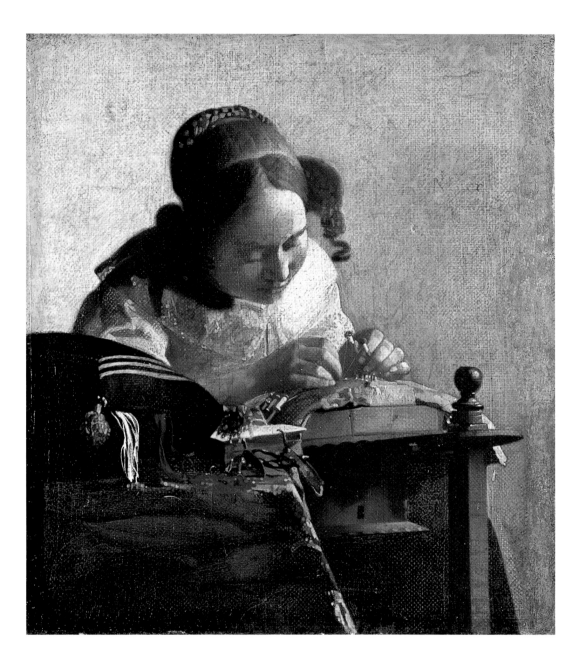

The Lacemaker

where a window is open, as in *Girl Reading a Letter at an Open Window* (p. 29), no noise at all from the street seems to disturb the quiet of the room. A similar tranquillity, unusual in such a location, is also suggested in the *View of Delft* (p. 42f.). In this respect, Vermeer stands apart from his contemporaries whose concept of painting was the very opposite of Vermeer's. A typical characteristic of Dutch painting is its anecdotal, colourful and frequently brash narrative form, coupled with a richly symbolic language derived from so-called emblem books that were hugely popular at the time. Such symbolic language was intended to strike a chord amongst viewers with regard to moral and social behaviour. The paintings by Haarlem's Adriaen van Ostade (1610–85), portraying brawling, drunken peasants, for instance, or the anecdotal and humorous interiors of Leiden's Jan Steen (1626–79) and Gabriel Metsu (1629–67) automatically come to mind in this respect.

Vermeer's pre-eminence as an artist is additionally due to his superior ingenuity as a painter and the meticulousness with which he not only reproduces what he sees in terms of the art of his day but also how he modifies it to suit his own ideas and almost imperceptibly manipulates the way the onlooker views his paintings.

A detailed description of the *View of Delft* illustrates this point (see p. 40f.). Comparable approaches are also apparent in many of his interiors. If one considers the rooms depicted, it becomes clear that Vermeer's aim was not to produce the perfect painting in terms

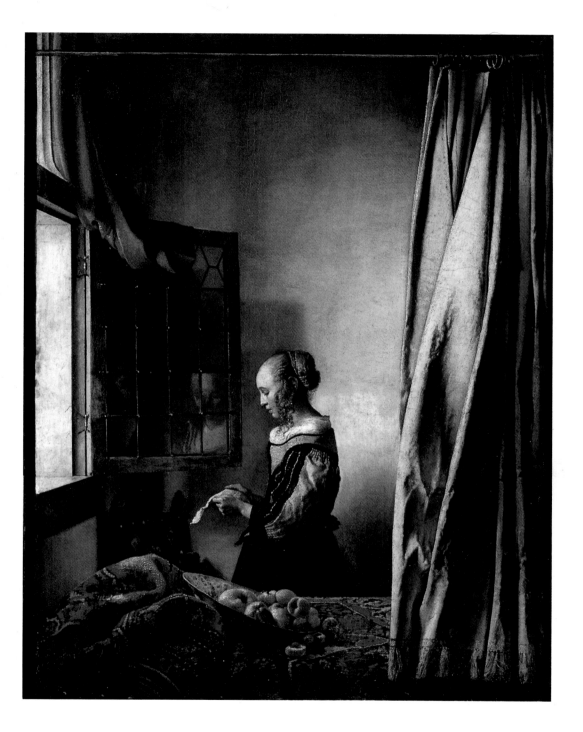

Girl Reading a Letter at an Open Window

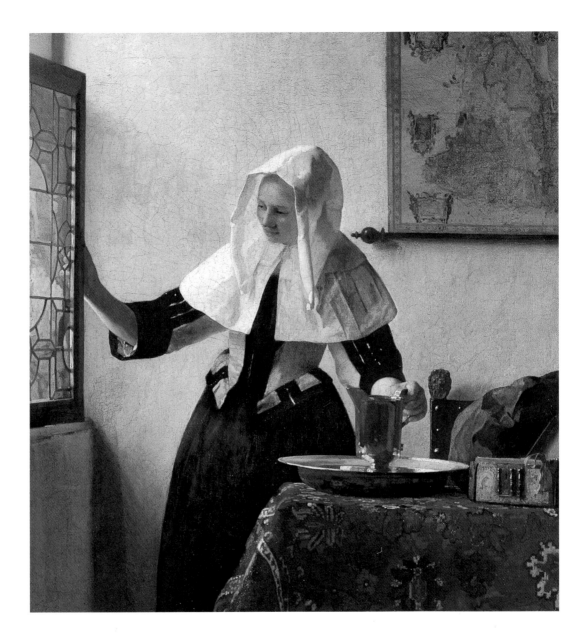

Woman with a Water Jug

of linear perspective, but instead, to use his own artistic ideas to create a spatial illusion and to influence the viewer's perception.

A consequence of Vermeer's exacting and time-consuming style of painting was that his output was far smaller than that of his contemporaries. Here, once again, he differs from artists such as de Hooch and others who thought nothing of returning to certain subjects on several occasions if they sold well. With his slow working methods, Vermeer did not suit the demands of commerce or capitalise on the possibilities of the then flourishing Dutch art market that he, as an art dealer, was in a good position to judge. This is why even then he placed a different kind of value on his work.

Except for the previously mentioned commission from the Jesuits, no other commissions are known that would have warranted Vermeer's working methods and possibly have guaranteed him a regular income. Even the large-scale *View of Delft* was not a commission. This meant that its high production costs had to be borne by Vermeer himself. His willingness to do so testifies to his passion as an artist and his conviction.

Vermeer's other paintings are almost exclusively small-scale works. Other than the *View of Delft*, the exceptions to this are *The Allegory of Faith* and *The Art of Painting*. All the paintings are oil on canvas except for *Girl with a Red Hat* and *A Young Woman with a Flute* (p. 89). These are his only oil paintings on panel; however, their attribution is still disputed. The same is

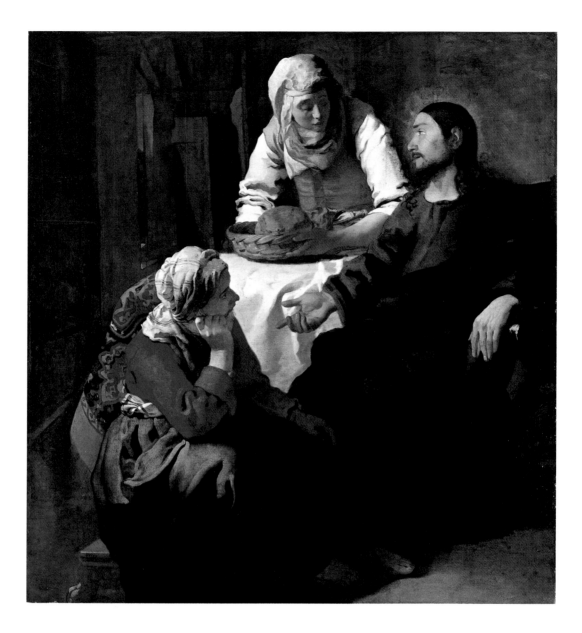

Christ in the House of Mary and Martha

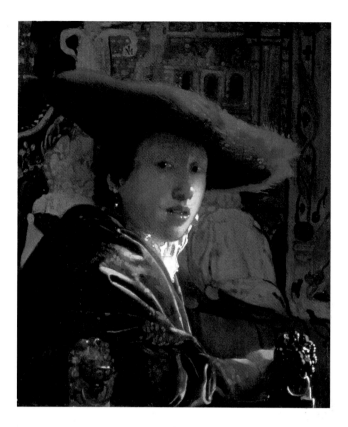

Girl with a Red Hat

true of the three, allegedly early paintings: *Saint Praxedes* (p. 34), *Diana and her Companions* (p. 35) and *Christ in the House of Mary and Martha* (p. 32). These are strikingly different from the rest of his œuvre because of their obvious religious and mythological subjects, their relatively broad areas of colour devoid of detail, the play of light and shade that is reminiscent of the Caravaggists and their compositional layout.

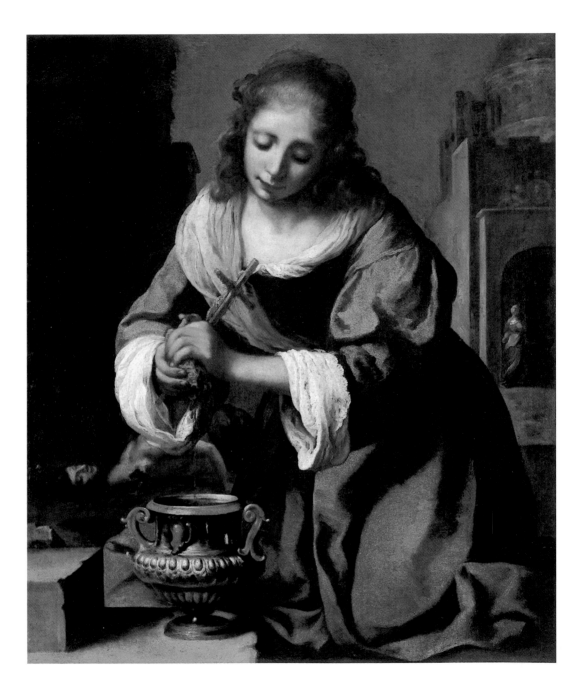

Saint Praxedes

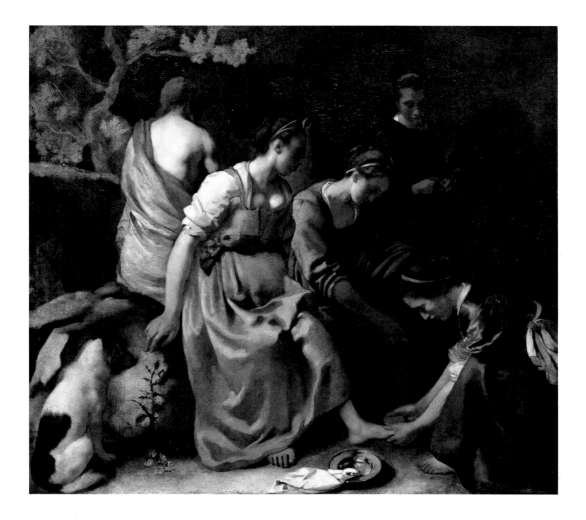

Diana and her Companions

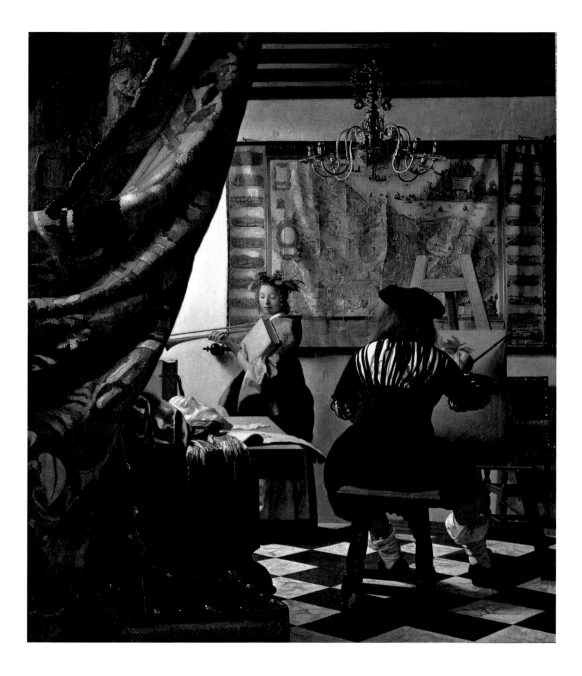

The Art of Painting

Johannes Vermeer's famous *View of Delft*

Due to a growing interest in cartography, artists increasingly viewed the townscape as a subject in its own right during the second half of the sixteenth and at the onset of the seventeenth century. To give map-users an impression not only of the geographical position of towns but also of their appearance, small pictures highlighting their most interesting features were positioned around the edge of maps, especially large ones. An attractive example of just such a map is seen on the rear wall in Vermeer's painting *The Art of Painting* (p. 36). Small-scale views of towns, like postcards today, were intended to give some idea of a town's size and grandeur. They proved very popular on printed maps and in atlases which, unlike the few large maps produced at that time, reached a greater circulation.

One of the most renowned graphic artists in this field was Claes Jansz. Fischer (1587–1652) in Amsterdam. Maps and books of this type continued to be printed and sold in large numbers throughout the seventeenth century and became ever more informative and detailed in their descriptions of places. Delft was the subject of various such publications, among them the detailed, large *Figurative Map of Delft* from 1675–78 (p. 38) showing a view of the town from the west, or a similar view from the south-west as seen by Dirck van Bleyswijck and published in his 1667 *Description of the*

37

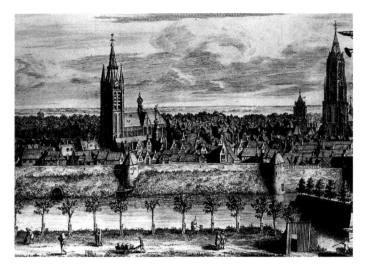

View of Delft from the West
Detail from the *Figurative Map of Delft*, Amsterdam 1675–78

Town of Delft. Both of these views were mainly intended as general illustrations and information for public dissemination which is why they are largely documentary in nature.

Only following a change in the artistic focus of Dutch painting and a specialisation in new genres from 1650 onwards, was the townscape able to shed its minor role and develop into a subject of some importance. However, only a few paintings of Delft by local contemporaries of Vermeer have survived. Among these artists are Hendrick Cornelisz. Vroom (1566–1640), Daniel Vosmaer (1622–after 1666), Egbert van der Poel (1621–64), Pieter de Hooch (1629–84) and Jan Jansz. van der Heyden (1637–1712). None of these artists painted the town from the same perspective as Vermeer and it is also noticeable that they made a particular point of emphasizing the buildings that are

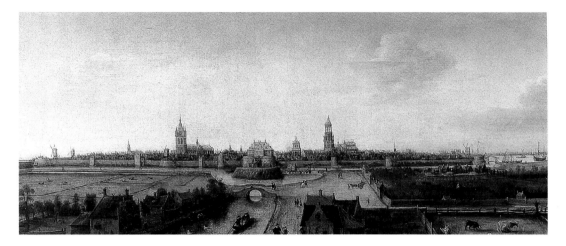

Hendrick Vroom
View of Delft from the South-west,
1615

the symbols of Delft—the New Church, the Old
Church and the Town Hall—or that they document-
ed important events in Delft's history, such as the
devastation wreaked on the town when its centrally-
located gunpowder magazine exploded on 12 October
1654 (p. 40). In other words, documentary and narra-
tive interest still predominated in their work, while
Vermeer in his *View of Delft* (pp. 42/43) develops a

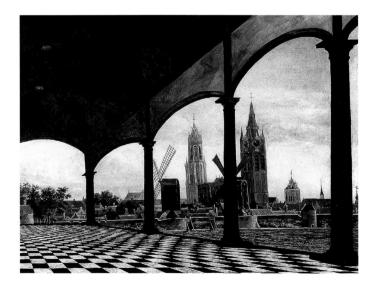

Daniel Vosmaer
View of Delft through a Loggia, 1663

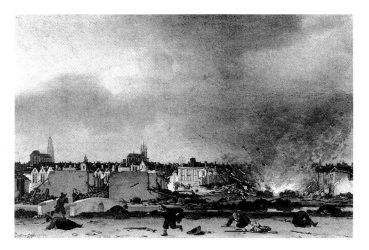

concept of painting that is far removed from theirs and is uniquely his own.

Vermeer shows us Delft from the south with its harbour alongside the canal leading to Rotterdam, Schiedam and Delfshaven. The sky arches overhead, covering more than half the canvas. In the foreground, a heavy cloud creates a rather gloomy atmosphere on the quayside; in contrast, things are brighter in the distance where the sun has broken through lighter clouds against a bright blue sky to illuminate the roofs. It is this very contrast between buildings in the shadow and the bright sky over the rest of the town, and the horizon that impressively emphasizes the picture's main subject—the town's skyline—highlighting its silhouette.

The painting was signed by Vermeer in the left-hand corner on the boat; although it is not dated, it was presumably painted around 1660–61. This large painting in oil on canvas measures 96.5 x 115.7 cm and is now held in the Mauritshuis in The Hague.

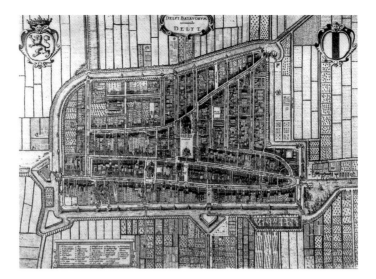

Johan Blaeu
Plan of Delft from the
'Stedenatlas' (town atlas), 1649

Vermeer's view of the town from the south can still be identified using seventeenth-century plans and engravings that have survived. In the 1649 map of Delft from Johan Blaeu's town atlas, it is not only possible to make out its compact and self-contained structure, including the many waterways and canals that even today characterise the town, but also the harbour to the south on the far right. A detail shows even more

Johan Blaeu
The Harbour at Delft, Detail
from the 'Stedenatlas', 1649

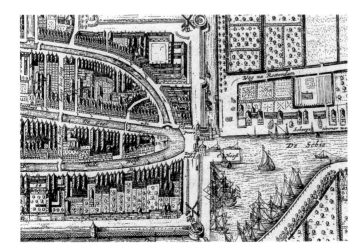

clearly how the River Schie flows from the right into the wide harbour basin. This is where Vermeer stood to paint his picture, or rather on the opposite bank, which is the scene he paints in the foreground. A small group of people standing on the same spot attracts the observer's attention and one is drawn

41

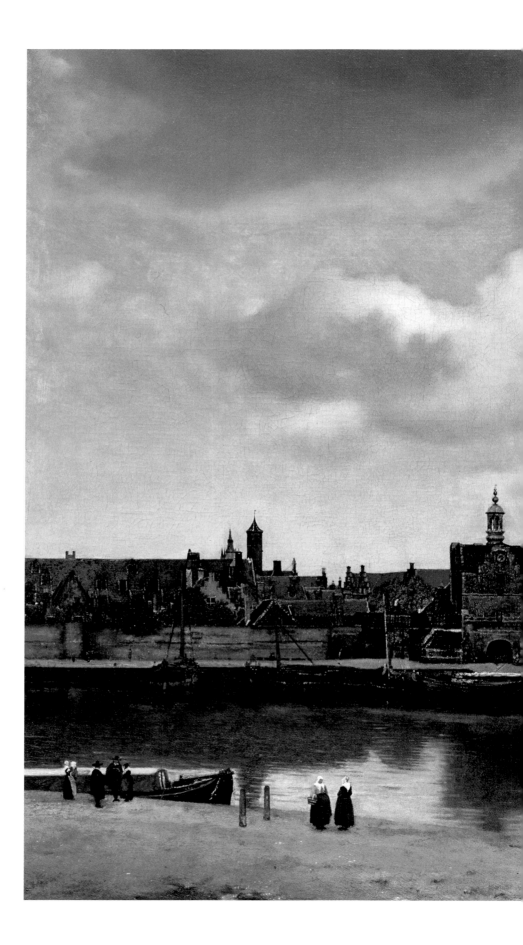

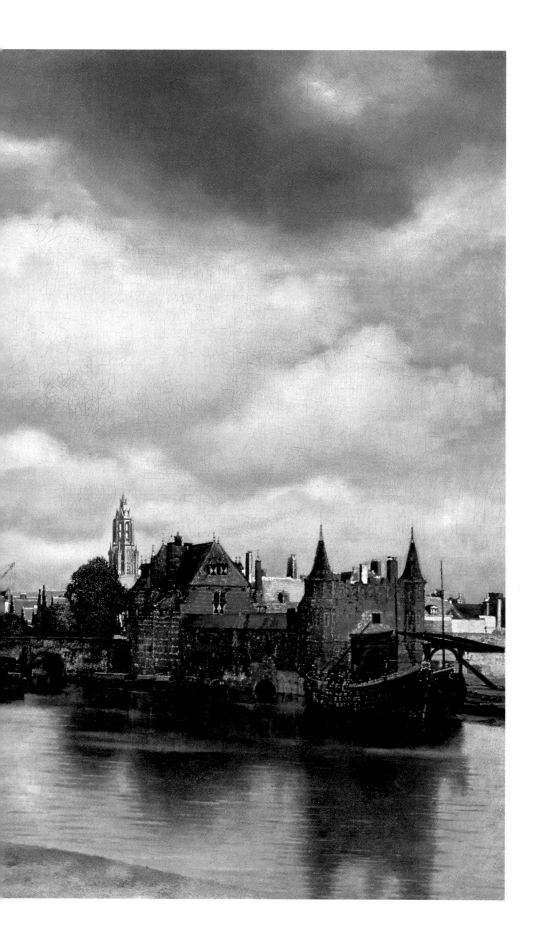

into the picture. Two women in typical country dress with white collars and bonnets are standing chatting to each other. Only a few feet away, alongside the barge tied up at the quayside, another group of two men and two women, one carrying a small child, stand talking to each other, concerned only with themselves and not paying any attention to what is going on at the harbour or in the town beyond. Vermeer 'bridges' the wide space between the figures in the foreground and the town by painting reflections of the large buildings opposite on the water; his reflections look more like long shadows on the water's smooth surface and reach across to the nearside quay. These help to draw the observer's eye from the small group of people across to the town where the focus is on the bulk of Schiedam Gate in the centre. In Vermeer's day, only the main section with its clockwork mechanism in the stepped gable and the roof lantern remained (p. 51). A small

View of Delft, detail showing the figures in the foreground

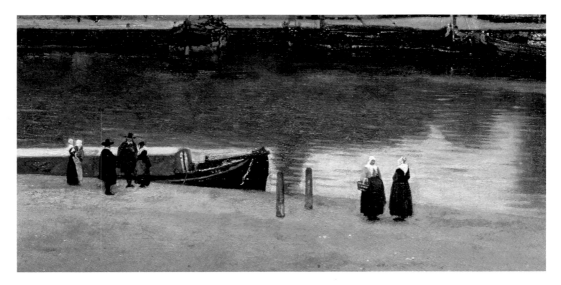

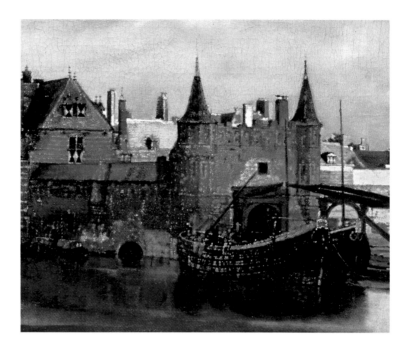

Detail showing
Rotterdam Gate

bridge leads away from it across the canal to the right towards Rotterdam Gate with its main inner gate and an outer portal with two towers. Immediately in front of it stands a double bascule bridge connecting both banks that, in Vermeer's day, led to the shipyard on the River Schie. Behind Rotterdam Gate's high gabled roof, still completely in shadow, bright sunshine illuminates the tower of the New Church and the adjacent rooftops of buildings along one of the main canals, the 'Langen Geer', that crosses the town and which is readily identifiable in Johan Blaeu's plan. On closer inspection, we see that there are no bells in the tower (p. 51). This is not due to an inaccuracy on the painter's part, however. Documents do indeed prove that when the painting was executed, the bells were no longer in the tower of the New Church, but had

been removed for renovation between 1658 and the summer of 1660.[9]

Vermeer worked very slowly on a painting, often taking several years to finish it. The *View of Delft* has been dated to 1660–61 on account of its stylistic features, a date that is confirmed by historical facts. On the left behind Schiedam Gate is the long roof of the Arsenal whose large factory-like interior housed Delft's gunpowder magazine. Nowadays it is occupied by the Netherlands Military Museum. Further to the left, the slender tower of the 'De Papegaeij' brewery rises above the rooftops and immediately next to it the tower of the Old Church can just be glimpsed. The long quayside runs parallel to the city wall where, just in front of Schiedam Gate, the small and unobtrusive Kethel Gate gives access from the town centre to the Schie quay. Some indistinct figures can be seen moving around the boats moored in front of the city wall and Kethel Gate, but they almost disappear in the shadow of the city wall. About ten barges of varying sizes are tied up peacefully with no discernible function along the quayside in front of the city wall, Schiedam Gate and alongside Rotterdam Gate.

A close study of the topographical features in the painting provides an accurate picture of the town in an historical context. Because the location can be seen to be real, the viewer can more readily identify with the place, can see himself as part of it, wander around it in his thoughts and gain a feel for people's customs and living conditions. This quite clearly differentiates a topographical landscape like this one from imagin-

ary landscapes that were also painted in the seventeenth century. When viewers can recognise something from the past, their imagination is fired; this is why the historical authenticity of Vermeer's *View of Delft* is of such significance. Yet such a description still does not allow the viewer to comprehend the painting fully. The great fascination that this painting exerts even to this day lies in reasons that are not as readily identified as its topography.

What strikes the viewer first is that the town and harbour appear unusually quiet. Nothing is moving; no ship is being loaded or unloaded, no sails are being set, no other ships are entering the harbour, no one on the quayside is selling the goods that have just arrived and the few people shown are in no hurry. The peace and quiet is echoed in the calm water in the harbour basin. None of these things reflects the noise, hustle and bustle that one would expect to find, especially considering that Delft's harbour was then an important centre of trade for a wide variety of goods moving between Rotterdam and The Hague. What is the explanation for this peace and quiet? Is it a Sunday or is it maybe early morning or even late evening?

The light in the painting is determined by the threatening cloud in the foreground and the bright sunshine in the background. It is not possible, however, to pinpoint the exact position of the sun. Neither the cloudy sky nor the buildings along the quayside are mirrored in the calm water in the harbour. Instead, long, dark shadows of the town's silhouette stretch across the basin to the other side.

Only a low evening sun could cast such long shadows. But in Vermeer's painting, the sun is still high enough to disappear behind the dark cloud in the foreground—in other words it must be above us—and breaks through only to the right of it to illuminate the town centre and the New Church. With the light at this angle, no such shadows would be possible. They should in fact then be very short and go in the opposite direction, away from us. In other words, Vermeer is staging a play of light in his painting, using it to satisfy his own compositional ideas. Restoration of the painting has revealed that Vermeer originally planned the shadow of Rotterdam Gate's twin towers to be shorter and only lengthened it to create a connection on this side of the painting between the foreground and the view of the town in a way that completes the composition. Moreover, x-rays of the painting have shown that Vermeer initially painted the twin towers in bright sunshine and that he only later decided to place them in the shade.[10]

The artist treats his colours similarly. At first sight, they appear muted and dark in the shade, while the orange and yellow of the sunshine appear all the brighter. On stepping closer to the painting, however, one can see a wealth of light and colour even in the shadow below the cloud that, indirectly, greatly influences the impression made by the picture. In relation to the dark cloud immediately above it, the quayside in the foreground is surprisingly light, almost yellowish. Vermeer thus connects the foreground and the background through the use of colour. The two women standing at the harbour are dressed in blue,

yellow, black and white. Vermeer makes much use of blue in his townscape, although it is not immediately apparent as one does not expect to see it where it is used. While the tiled roofs on the left-hand side behind the city wall are red, the roof of Rotterdam Gate is painted using a bright blue. The plaque on the bridge between Rotterdam and Schiedam Gates is emphasized using the same blue dots. The leaves on the trees behind the bridge and between the houses have also been painted using spots of colour that over the centuries have changed from green to blue. Where the barges are tied up at the quayside in front of Kethel Gate, blue, yellow and white dots again catch one's eye as they also do along the sides of the barges. There is no explanation for such diffuse light here. It is especially noticeable on the barge to the right of Rotterdam Gate. More spots of light have been painted here in a complicated technique, partly wet on wet, and have been applied in various shades of ochre, grey and white that enliven the side of the barge and make it stand out against the dark shadow that is cast across the river's surface. A reflection on the water is suggested in this way, but in the shade no reflection would be possible. Through the use of such details Vermeer modifies a seemingly true-to-life portrayal in favour of his own ideas. Across almost the whole of the canvas, countless small and bright dots can be seen that lend the painting—its houses, roofs, barges and tree—a colour and brightness of their own, divorced from that of natural daylight and which, in addition, give the subjects a subtly distinctive surface texture.

Detail of barge moored outside Rotterdam Gate

Despite such 'discrepancies' in light and colour, the painting's powerful realism is derived on the one hand from the fact that the viewer recognises the local scene and, on the other, from the subtle differences between the surface textures of the painted objects. Vermeer uses various techniques to characterise the different types of buildings, the material qualities of the brick walls, the roof tiles and windows as well as the trees and the water. In some places he applies his paint smoothly and gently, in others it is put on thickly and in several layers. He even mixes sand into his oils, thereby causing optical irregularities and giving the impression of a grainy, coarse surface. The row of red roofs to the left of Schiedam Gate thus takes on a brittle and raw quality. Moreover, each of the roof tiles is hinted at singly by means of a thin, reddish-brown coat of varnish showing tiny spots of red, brown and blue. In the case of the stepped gable with its central window, Vermeer differentiates between the smooth glass in the window and the yellow rough-cast wall by painting the glass lightly and smoothly and by mixing sand in his oils for the white window frame and the wall and applying them thickly and coarsely.[11] In contrast, thick white opaque paint is used to express the properties of the hastily-struck white sail on the boat moored in front of Schiedam Gate. The sunlit rooftops in the background and the tower of the New Church also reveal the use of impasto that reflects the light and makes the colours appear all the more radiant. The lead-tin yellow sections of the New Church tower that are caught in the sunlight look sculpted, appearing almost three-dimensional.[12] Such fine adjustments to his compos-

Detail of the roofs near Schiedam Gate

Detail showing small-paned window

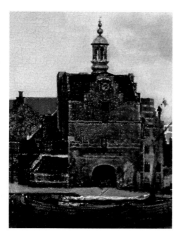

Detail showing Schiedamer Tor

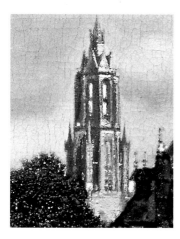

Detail showing the New Church

ition clearly show how much Vermeer was concerned with detail when trying to reproduce his subject realistically. At the same time, he distances himself from reality and decides for himself what kind of light and colours he would like to see his hometown of Delft in and from which perspective; in other words he considers how he sees it in his mind's eye and develops his own image from that.

Vermeer's use of a 'pointillistic' technique, with which he creates a diffuse light, causes a certain fuzziness that becomes apparent only when the painting is viewed at close range. At a distance, his details blend to form a picture that gives an overall homogenous, atmospheric effect. This technique is not to be confused with an Impressionistic one, however, even if it is reminiscent of the latter. This examination of the painting has shown that Vermeer's concern as an artist was not to capture the light of a particular moment at a particular time of day. His use of light is based on compositional considerations and is used to define material qualities. There probably never was such a day as the one depicted in *View of Delft*. The location may be real, but the situation is not. In this painting Vermeer removes his hometown to another unearthly world beyond the human dimensions of time.

An eighteenth century drawing (p. 53) by Abraham Rademaker (1675–1735) shows Delft from the very same viewpoint as in Vermeer's painting, looking across the harbour towards Schiedam and Rotterdam Gates. For this reason it is the only image that is suitable for comparison purposes, even though it may have been drawn some fifty years later.[13] Moreover, because Rademaker's is a drawing, its character is different to that of a painting. Its main purpose was to capture topographic details on paper and to remind one of the place in question. Unlike Vermeer's painting, it should not be viewed as a properly thought-out composition; a drawing like this was used rather as a model for a painting done later from memory in a studio. Yet it is the drawing's study-like character that suggests that Rademaker's concern was to reproduce the townscape's topographic and perspectival detail as closely as possible.

The differences between Rademaker's work and Vermeer's painting can be clearly seen. What is immediately noticeable is that the two gates in the drawing are not so far apart and are set at a different angle than those in Vermeer's painting. He depicts Schiedam Gate with its clock tower from a different perspective: the building stands at right angles to the viewer so that its façade, and not its side, is seen—as is the case in Rademaker's drawing. The twin towers of Rotterdam Gate in Vermeer's painting are positioned much further forward, while Schiedam Gate is set further back. Adjacent Kethel Gate forms an inconspicuous part of the city wall in Vermeer's painting, but in the drawing is shown as a large entry point into the town.

Abraham Rademaker
*View of Delft with Schiedam and
Rotterdam Gates*

The bridge connecting both gates is much wider in
Vermeer's painting and allows a distant view of sunlit
rooftops on the houses along the 'Lange Geer' canal.
The field of vision in the drawing is more restricted
and does not allow a view of the town's roofscape. The
same is true of the New Church spire that in Ver-
meer's painting is sunlit, taller and positioned more to
the right than in Rademaker's drawing in which it is
further away, much smaller and seems less important.
The roofs, stepped gables, chimneys and towers in
Rademaker's drawing are more irregular and pointed
and are higher or lower than in Vermeer's painting.
The overall impression of the town's silhouette is thus
much less peaceful and more energetic. A comparison
with Rademaker's drawing illustrates several points:
Vermeer has modified Delft's skyline to suit his own
compositional ideas; he has rendered the rooftops
more evenly and the chimneys and stepped gables

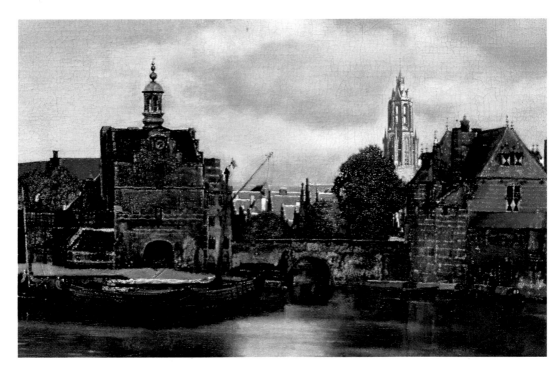

Detail of Schiedam Gate and the church tower

have been included in the overall picture less conspic-
uously; he has also made some changes in perspective
with the aim of creating an impression that is as bal-
anced and uniform as possible, even if it had little to
do with the town's actual topography.

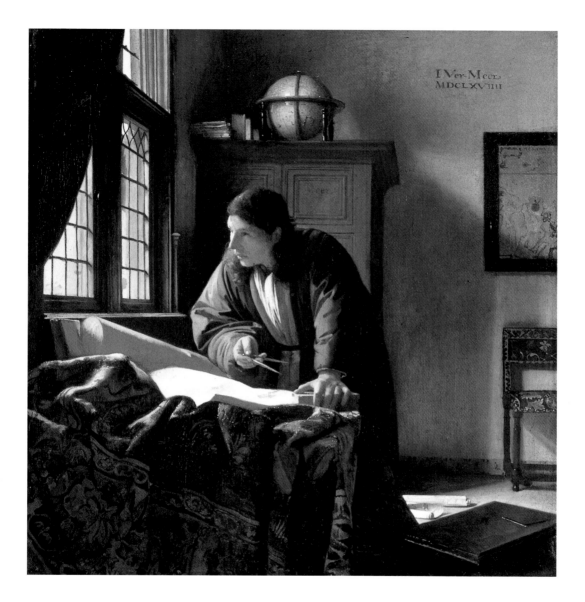

The Geographer

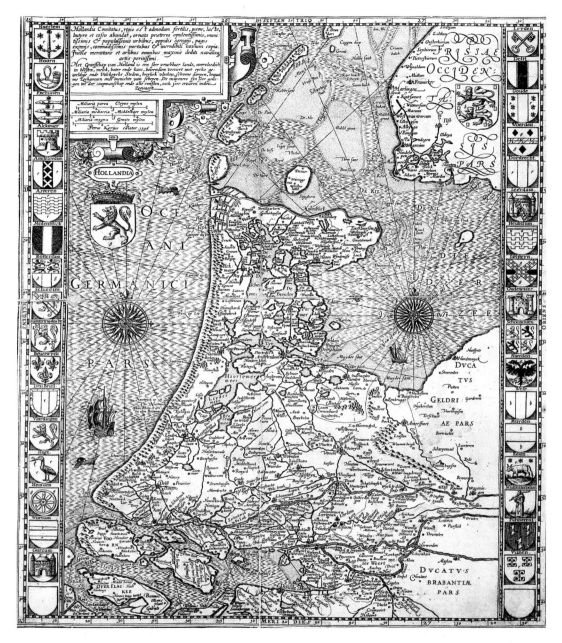

Petrus Kaerius Caelator, *Map of Holland*, 1596

The Artist's Hometown
in the 17th Century

Even in Vermeer's day, the town of Delft, characterised by its city wall and fortifications, could look back on a long and eventful history that had left its mark on the town's cultural and social life. To explain Delft's particular historical importance in the political development of the Netherlands and its close ties with the House of Orange, one has to go back to the sixteenth century.

The Netherlands originally comprised seventeen provinces within the territories of the present-day Netherlands and Belgium—provinces that had emerged from numerous earldoms, duchies and dioceses which Charles V had gradually united by 1548. In 1556 he handed over control of the area to his son, King Philip II of Spain. The radical changes occasioned by the Reformation in the intellectual and religious life of northern Europe had also taken hold in the Netherlands. In the course of the subsequent Counter-Reformation, Spain, in the interests of Roman-Catholic authority, began to exert increasing pressure on the Low Countries. Philip II made William of Orange the provincial governor or *stadhouder*. As a confidant of Charles V, he occupied a senior political post. Together with the counts Egmond and Hoorn, he was concerned in ensuring as tolerant a policy as possible, but was unable to realise one in the face of opposition from Margaret of

Claes Jansz. Visscher
Equestrian Portrait of William of Orange, detail from the *Map of the Seventeen Provinces*, 1636

57

Austria, the Duchess of Parma, and her chief adviser Granvelle. The Spanish claim to power, underpinned by military means, meant that the Dutch nobility's local privileges and religious freedoms were being increasingly curtailed. Resistance to Spanish rule culminated in 1566 when radical Protestant masses ransacked Catholic churches. Philip II then sent the Duke of Alba to the Netherlands at the head of an army that was to use force to re-establish the king's order. Numerous executions followed, including those of the counts Egmond and Hoorn, by then viewed as resistance leaders. William of Orange fled to Germany where, in his ancestral home at Dillenburg in Hesse, he organised resistance to Spain's dictatorial policies, the Duke of Alba and his troops and the violation of his own aristocratic privileges. In 1572 twelve towns elected him *stadhouder* of the provinces of Holland, Seeland and Utrecht. When, in 1580, Philip II placed a bounty on the head of William of Orange, the northern provinces of the Low Countries, assembled in the Binnenhof at The Hague, rejected the king of Spain and appointed William of Orange as regent. He moved his seat of government from there to Delft's Prinsenhof, formerly the nunnery of St Agatha, where he felt more secure from Spanish persecution and where he, in fact, survived several assassination attempts.

In the 1579 Union of Utrecht, seven northern provinces—Holland, Seeland, Utrecht, Geldern, Overijssel, Friesland and Groninge—formed a union under William I of Orange and in 1581 finally broke away from Spain and the House of Habsburg to form their own republic, the United Provinces. The remaining

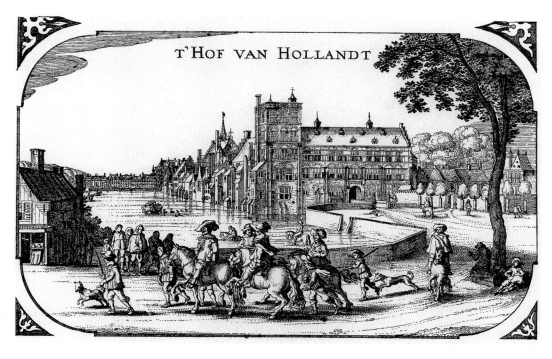

t'HOF VAN HOLLANDT

Claes Jansz. Visscher
The Binnenhof in The Hague,
detail from the *Map of the
Seventeen Provinces*, 1636

ten southern provinces, including Antwerp, remained under Spanish control after the Duke of Alba was succeeded by Alexander Farnese, Duke of Parma, in 1585. The border between Brabant and Flanders and Holland thus developed into a permanent one between the northern and southern provinces. It split the Netherlands into two parts, each fundamentally different in character and structure. During the armistice of 1609–21, the northern provinces were able to assert their independence that was finally given international recognition in the 1648 Treaty of Westphalia.

Following the assassination of William I at the Prinsenhof in Delft in 1584, his successors from the House of Orange moved back to the Binnenhof in The Hague that had been the seat of government for

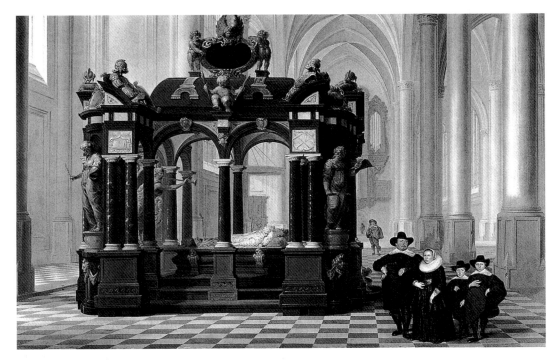

Dirck van Delen
The Tomb of William I of Orange,
1645

the United Provinces of the Netherlands since 1575 (p. 59). Delft nonetheless retained close ties with the ruling House of Orange and William I was buried in the town's New Church where an impressive monument was erected in 1622 to commemorate his political activities that decisively influenced the fate of the northern provinces.

The *stadhouder* Frederik Hendrik died in 1647 and his son, William II, died shortly after him. The Dutch Republic thus had no *stadhouder* between 1648 and 1672. Because of this unexpected development, it fell to the patrician classes to govern the country. Under Johan de Witt, the acting head of government, a long period of stable internal politics and great economic success followed from 1653 to 1672—coincidentally Vermeer's main creative phase. With the Dutch East

India Company and possessions in Africa and the Americas, the United Provinces became Europe's leading trading and sea power for a time with a fleet larger than England's. It is in this context that the Dutch talk of a 'Golden Age'. Thanks to a flourishing maritime trade and an open market economy, sugar refineries, tobacco-processing plants, breweries, shipyards, textile mills, and other new industries developed. Delft's porcelain factory, still famous to this day, was also founded.

Trade encouraged the production of maps and nautical charts, globes and atlases. As a seafaring and trading power, the United Provinces had a vital interest in geography as a means of developing their own territories and maritime possession. The huge popularity of topographical and town maps also reflected the new political self-confidence of the citizens of the United Provinces. In some of his interiors, Vermeer includes large maps of the seven northern provinces (pp. 64, 65). The purpose of maps in the home or in public buildings such as the town hall was not so much ease of orientation; their large format alone suggests that they were intended to demonstrate the importance of a town or country.

Historical maps show that the distances between the towns in the province of Holland were small and that they could easily be covered on its extensive network of canals (p. 56). Ferries carrying goods and people ran to timetables to ensure smooth and regular connections between different towns. A glance at a map of Delft (p. 41) shows that, even within the city walls,

most goods could be transported by barge. The wide-
spread network of canals called for as many crossings,
however, and the numerous small bridges in Delft
were well suited to everyday trade in goods and food.
Most professions, and especially the skilled trades,
were carried out from home. Workshops and shops
were situated on the ground floor with access to the
street. Living quarters were found at the rear of the
building overlooking the courtyard or upstairs. Many
interiors by artists such as Pieter de Hooch, Emanuel
de Witte, Pieter Janssens Elinga and other local
painters vividly capture daily life in the streets and
homes of Delft at the time.

The face of Delft is characterised by the canals, the
mills and the city wall with its twenty-four towers
that lend it a fortified appearance. Seven large gates,
situated on the main canals, allowed access into the
town. As old maps show, the main entrances in the
south of the town were Schiedam Gate and Rotterdam
Gate with the adjacent quayside; East Gate and, in the
north, Hague Gate leading to The Hague, Leiden,
Haarlem and Amsterdam. For his painting, Vermeer
chose one of the main entry points into Delft. Within
the wall surrounding the town, the Old Church and,
opposite it, the Prinsenhof on the 'Old Delft' canal, as
well as the New Church and the Town Hall on the
spacious main square, were among the town's fore-
most buildings (p. 66). The original Town Hall dated
from the fourteenth century, but a fire in 1618 des-
troyed all but the tower. Hendrik de Keyser, the sculp-
tor responsible for the tomb of William I in the New
Church, rebuilt the Town Hall in the Renaissance

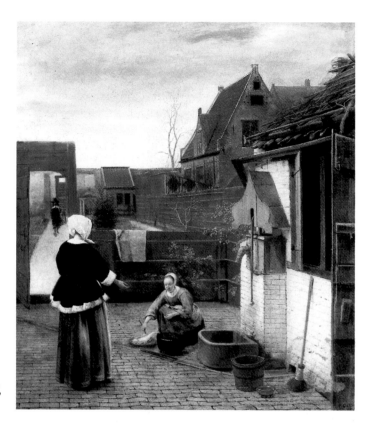

Pieter de Hooch
A Woman and her Maid in a Courtyard,
c. 1660

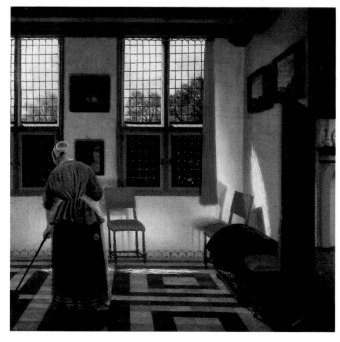

Pieter Jannsens Elinga
Woman Sweeping

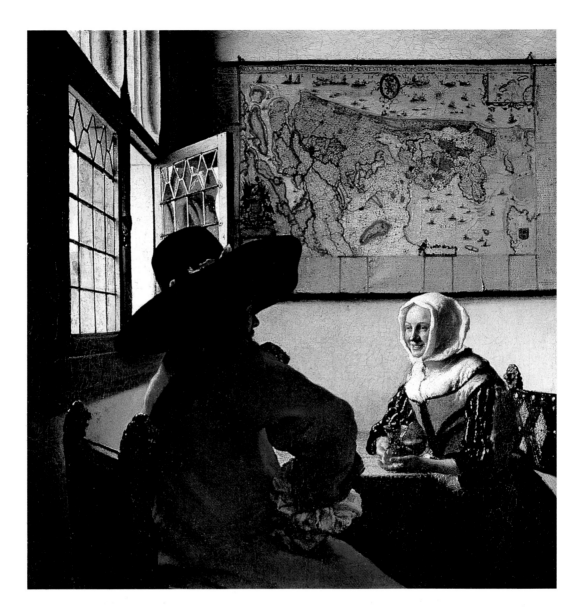

Soldier with a Laughing Girl

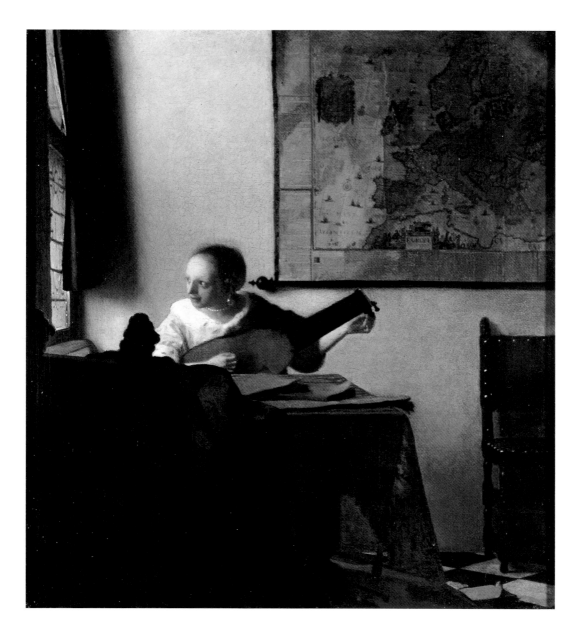

Woman with a Lute

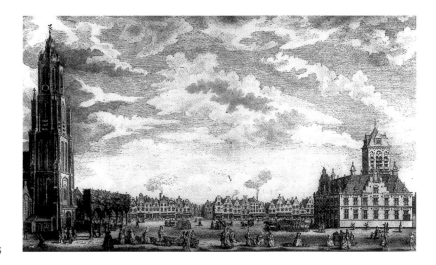

style. The 'Mechelen Inn', acquired by Vermeer's father in 1641 as a business and home for his family, was located on the main square where the weekly market and many other events were held (p. 67). The towers of the Old Church and the New Church, Delft's only two large churches, soar above the rooftops of the town to this day. The Gothic Old Church was begun in the thirteenth century while the New Church, situated on the Market Square opposite the Town Hall, was first built in wood towards the end of the fourteenth century and was not completed in stone until 1496. Formerly Roman Catholic churches, they were rededicated as places of Calvinist worship after the Catholic churches had been ransacked in a popular uprising. Calvinism was the main religion of the United Provinces in the seventeenth century, although it was never officially declared the state religion. While Lutherans, Jews and Mennonites were tolerated, only Catholicism was prohibited. Nevertheless, many wealthy Catholics were still present in the country as a whole and also in Delft. These

included refugees from the southern provinces who were quietly tolerated. While they had to forgo the use of large churches, they nonetheless continued to celebrate mass which was something of an open secret. Delft's Catholics held their masses in a house overlooking 'Oude Langendijk', a canal south of the main square, but this building has not survived.

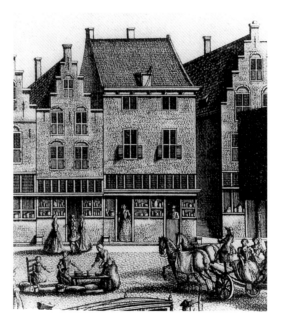

Abraham Rademaker
The Mechelen Inn (detail from *Gesicht op de Markt*), *c.* 1720

Owing to the large number of Catholics who lived here, the area was known as 'Papists' Corner'.

The political, economic and religious differences between the north and south had consequences for the development of art in both areas. In the southern provinces, the church and the monarchy remained the main sources of artists' commissions; in the northern

67

Abraham Rademaker
The Jesuit Church in Delft,
c. 1720

provinces, however, a free art market developed. In other words, artists painted pictures without being commissioned to do so and hoped that they would be able to sell them later either themselves or through an art dealer. The free market did not guarantee artists a secure income, of course, which is why most of the artists working in the United Provinces, with few exceptions, simultaneously had other jobs that would earn them a living. Town councils, guilds and other private and public bodies still continued to commission large-scale works for public buildings, although the *stadhouders* themselves provided only a limited number of commissions for artists, and none of them collected the work of artists like Frans Hals, Johannes Vermeer, Jan Steen or Jacob Ruisdael, or even supported them. The members of the ruling House of Orange had, in fact, more of a liking for traditional Flemish Baroque as exemplifed by its most prominent artists Peter Paul Rubens and Anthony van Dyck. The buoyant economy, however, allowed many people in the United Provinces to acquire art for their own homes and thus to enhance their social status. In keep-

ing with this new clientele and their demands, there was a change in the subjects favoured by artists. Unlike in the Catholic southern provinces, there was now almost no demand for religious art in the Calvinist Dutch Republic. Here the focus was on everyday life as experienced in the streets, at the market, in inns, courtyards or in the home. Subjects also included precious objects like magnificent goblets, exotic fruit and elaborate glasswork. People's newfound self-esteem prompted them to make themselves and their immediate environment the focus of attention. The many genre paintings and domestic interiors from this era, however, are not merely duplicating the typically Dutch style; rather they reflect life in an expression of both pride and confidence. The same is also true of the many townscapes that were painted in the United Provinces in the seventeenth century. They reflect the new way in which the citizens of the Dutch Republic began to identify with their history and culture, a way that would have been unimaginable in the southern provinces where political conditions in the seventeenth century were quite different.

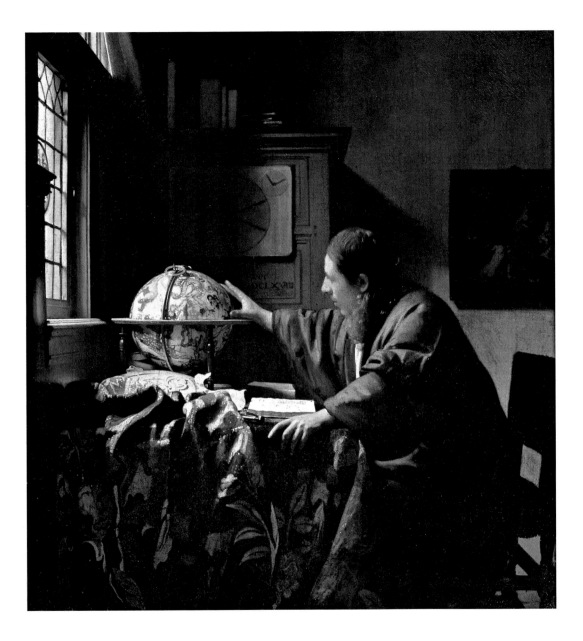

The Astronomer

Vermeer's World:
Thoughts on
the Artist's Intentions

A look back at history shows that Vermeer's main creative period between 1650 and 1670 coincided with what in many respects was a time of prosperity and peace, both for the United Provinces and the artist's native town of Delft. The economy was thriving and brought wealth to town and country alike; Vermeer and his family most certainly also benefited. It seems obvious to suppose that historical, political and personal reasons prompted him to select a view of his home town as the subject for a large-scale painting, but there's no doubt that by choosing it, he *was* expressing his close attachment to Delft. The New Church tower, captured in bright sunlight, might therefore also be of symbolic importance. Yet it appears not to have been in Vermeer's interest to make a clear political statement; otherwise he would have positioned the New Church more to the fore as many of his contemporaries did in their paintings. Instead, the tower merges into the overall townscape and even appears to be surpassed in height by the clock tower of Schiedam Gate. Rather than being too obvious, Vermeer employs contrasting light and shade with great subtlety to draw the viewer's attention towards the New Church tower in the background and thus at least hints at a historical and political message as the tomb of William 1 of Orange is to be found in the church.

Vermeer is similarly restrained in recording his country's economic success during its 'Golden Age'. His *View of Delft* does *not* show the lively activity associated with the flourishing trade from which Delft in particular benefited. The atmosphere at the quayside is strangely quiet and the town appears quite modest. The noise and hustle and bustle of everyday life have been banished from Vermeer's painting. Although Vermeer chooses a view of his hometown as the subject of a large-scale painting, he tells us nothing about the real importance of the place or about its particular layout or contemporary or historical events. Anyone looking at the painting does not associate any sounds, noise, voices or church bells with it. The few figures standing at the quayside in the foreground appear to be enshrouded in silence.

Similarly, the viewer learns just as little about Vermeer's own life in Delft. He completely excludes his family from his paintings and one is left wondering what has happened to his own large brood of children. They must have dominated his every day and caused no end of noise.

Dutch artists in the seventeenth century became increasingly interested in the issue of perspective and the technical aids that were then being developed, although Vermeer's interest in them was less than that of his contemporaries. It is no longer possible to tell which optical instruments Vermeer may have experimented with, if indeed he used any at all. There is no conclusive evidence in his paintings that he did. Because of the many blurred spots of colour and light

in the *View of Delft*, and in some of his interiors (p. 30), it was believed that Vermeer might have used a *camera obscura* (p. 21) as an aid when composing his paintings.[14] When considering the underlying meaning of the painting this is of little significance, since Vermeer's art is not characterised by its photographic realism but by its distinctly painterly qualities. It is interesting to consider this with regard to Vermeer's dialectic relationship with deviations from accurate topographic depictions on the one hand and the meticulous precision with which he reproduces details on the other.

Vermeer obviously took great care when reproducing details from life. He lavishes so much attention on each small section and has such high regard for them all that any one could be removed from its context and could form a picture in its own right with its own meaning.[15]

The main difference between Vermeer and his contemporaries thus lies mainly in the way Vermeer translates his subject into art. No other Delft painter mastered the art of painting or recognised its expressive possibilities to the same degree as Vermeer and none of his colleagues worked with the same subtle artistic invention and meticulousness. Daniel Vosmaer (p. 39) and other Delft painters, for instance, were more interested in other compositional elements such as perspective. It is the extreme painterly intensity and the strikingness of the painting, however, that particularly distinguish Vermeer's *View of Delft* from other contemporary images of the town and

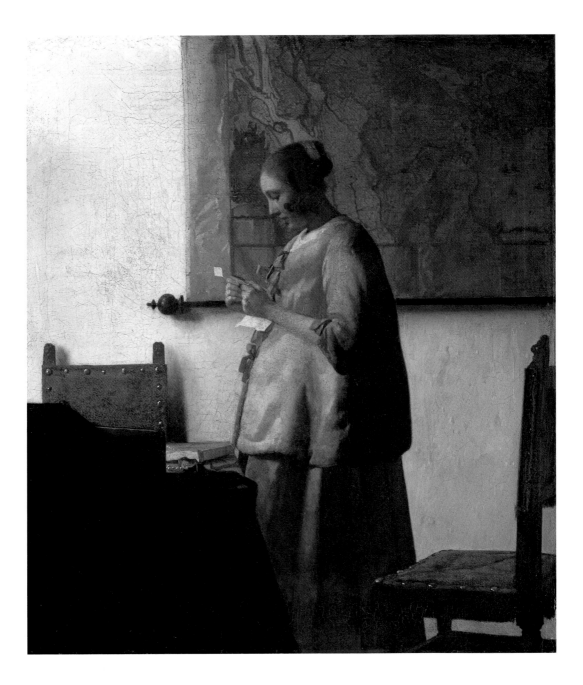

Woman in Blue Reading a Letter

also remove it from the tradition of topographic views.

Neither the painting's subject nor any anecdotal asides should distract us from Vermeer's main concern, the painting itself, art, composition, colours, details and the effect they can have on the human soul. Vermeer's view of Delft is thus not a "view" in the usual sense because he is not looking outwards "at" anything; rather his gaze is directed inwards.

Vermeer's image originates in his mind's eye which takes in reality as if seen through a spiritual filter, changes it into an image in its own right, composes it anew and intensifies it.

Something similar is evident in Vermeer's interiors, too (pp. 74, 77). Unlike the townscapes of his contemporaries, Vermeer's *View of Delft* is far more reminiscent of an interior than a landscape, the original source of the townscape. At the same time, this fact gives rise to the painting's temporal permanence[16] and thereby creates conflicting impressions of closeness and distance, familiarity and surprise, fascination and amazement. Just as Vermeer withdraws into his art from his hectic everyday life, giving himself over to a separate inner world[17], so too does the viewer for whom seeing also becomes a creative process. Despite the recognizability and representationalism of the painting's subject which has its roots within the permanent flux between reality and illusion[18] in art, the viewer's experience of Vermeer's *View of Delft* is mainly an abstract one, thus accounting for the painting's

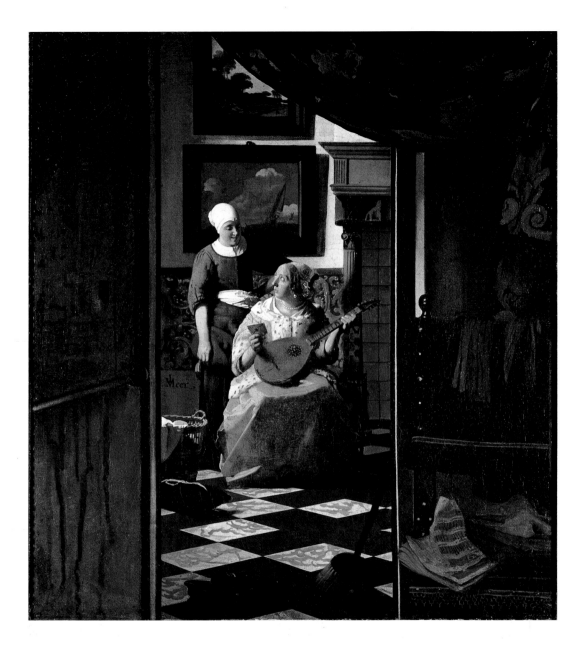

The Love Letter

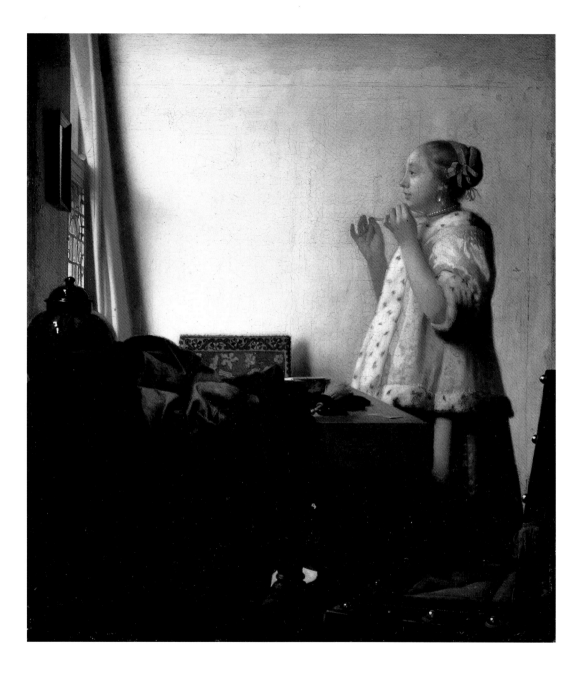

Woman with a Pearl Necklace

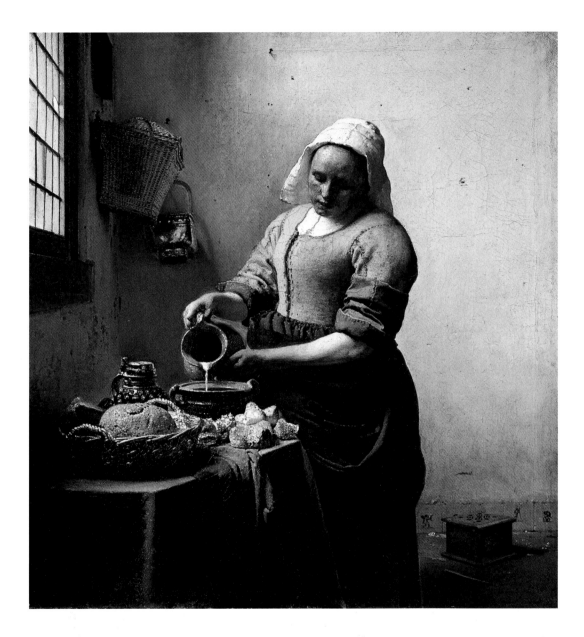

The Milkmaid

topicality to this day. Having transcended the passage of time, Vermeer's composition allows us even now to "step out" of the present for a moment's peace, to rest and gather our strength. It helps put some distance between ourselves and the world and to view life from a different perspective and maybe also to learn something about its nature and meaning.

1 Vermeer's biographical details in this chapter are based on research by John Michael Montias and Arthur K. Wheelock. See John Michael Montias, *Vermeer and his Milieu – A Web of Social History*, Princeton 1989; Arthur K. Wheelock, *Vermeer & the Art of Painting*, New Haven, London 1995; ibid. (ed.), *Vermeer. Das Gesamtwerk*, Stuttgart, Zurich 1996

2 See e.g. Susan Vreeland, *Mädchen in Hyazinthblau*, Munich/ Zurich 2000

3 cf. Daniel Arasse, *Vermeer's Ambition*, Dresden 1996, p. 25

4 cf. Gregor J. M. Weber, '*Caritas Romana*, a newly discovered painting in a painting by Johannes Vermeer'; in Weltkunst, issue 2, Feb. 2000, pp. 225–28

5 cf. Montias, ibid, p. 309, doc. 249

6 cf. Montias, ibid, p. 309, doc. 251

7 For a more extensive treatment cf. Walter Liedtke (ed.), *Vermeer and the Delft School* (exhib. cat., The Metropolitan Museum of Art, New York), New Haven, London, 2001, p. 250ff.

8 cf. Daniel Arasse, ibid, p. 28

9 cf. Kees Kaldenbach, 'Ein Flug über die *View of Delft*. Jan Vermeer's Meisterwerk von 1660 als virtuelle Welt,' in: *Weltkunst*, 69th year, no. 2, Feb. 1999

10 cf. Arthur K. Wheelock, 'Pentimenti in Vermeer's Paintings: Changes in Style and Meaning,' in: H. Bock and Th. W. Gaethgens (eds.), *Holländische Genremalerei im 17. Jahrhundert*, Jahrbuch Preußischer Kulturbesitz, vol. 4, Berlin 1987, pp. 385–412, p. 400ff.; also: Arthur K. Wheelock (ed.), *Vermeer. Das Gesamtwerk*, Stuttgart/Zurich 1996, p. 124

11 See Jorgen Wadum's restoration report in: *Vermeer illuminated. Conservation, Restauration and Research*, The Hague, 1996, p. 14 and p. 30ff.

12 cf. Arthur K. Wheelock (ed.),1996, ibid, pp. 120ff.

13 cf. Arthur K. Wheelock and C. J. Kaldenbach, 'Vermeer's View of Delft and his Vision of Reality,' in: Artibus et Historiae 3, no. 6 (1982), pp. 9–35

14 cf. Arthur K. Wheelock's examination of *Girl with a Red Hat* (p. 33) in: Arthur K. Wheelock (ed.), 1996, ibid, p. 160ff.

15 cf. Hubertus Schlenke, *Vermeer mit Spinoza Gesehen*, Berlin 1998, pp. 39ff.

16 cf. Irene Netta, *Das Phänomen ›Zeit‹ bei Jan Vermeer van Delft*, Hildesheim 1996

17 cf. H. Schlenke, ibid, p. 59

18 cf. H. Schlenke, ibid, p. 64

The Complete Works

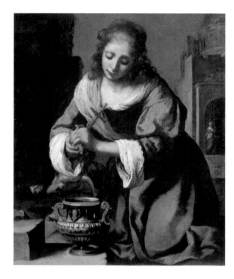

Saint Praxedes, 1655
Oil on canvas, 101.6 x 82.6 cm
The Barbara Piasecka Johnson
Collection Foundation, Princeton
Page 34

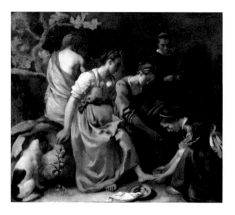

Diana and her Companions, c. 1655–56
Oil on canvas, 97.8 x 104.6 cm
Royal Cabinet of Paintings
Mauritshuis, The Hague
Page 35

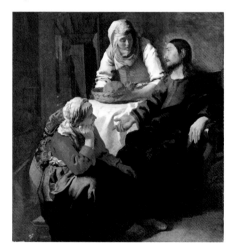

Christ in the House of Mary and Martha,
*c.*1655
Oil on canvas, 160 x 142 cm
National Galleries of Scotland, Edinburgh
Page 32

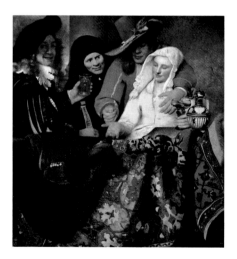

The Procuress, 1656
Oil on canvas, 143 x 130 cm
Staatliche Kunstsammlungen,
Gemäldegalerie Alte Meister, Dresden
Page 12

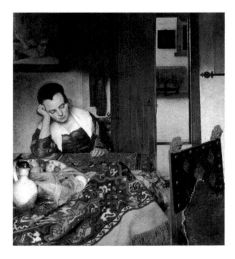

Sleeping Girl, c. 1657
Oil on canvas, 87.6 x 76.5 cm
The Metropolitan Museum of Art,
New York, Bequest of Benjamin Altman,
1913

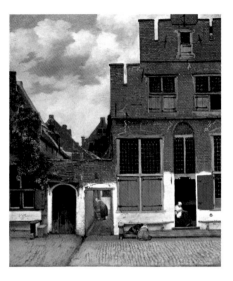

The Little Street, c. 1657–58
Oil on canvas, 53.5 x 43.5 cm
Rijksmuseum, Amsterdam
Frontispiece

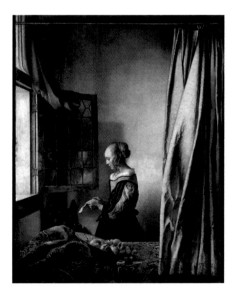

Girl Reading a Letter at an Open Window,
c. 1657
Oil on canvas, 83 x 64.5 cm
Staatliche Kunstsammlungen,
Gemäldegalerie Alte Meister, Dresden
Page 29

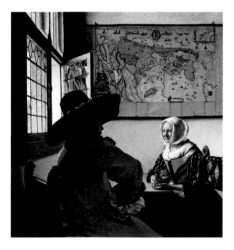

Soldier with a Laughing Girl,
c. 1658–60
Oil on canvas, 50.5 x 46 cm
The Frick Collection, New York
Page 64

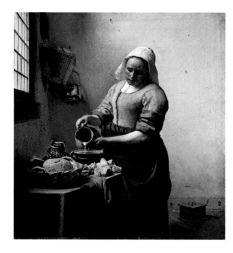

The Milkmaid, c. 1658–60
Oil on canvas, 45.4 x 40.6 cm
Rijksmuseum, Amsterdam
Page 78

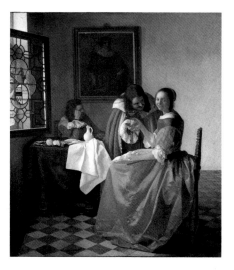

The Girl with the Wineglass, c. 1659–60
Oil on canvas, 77.5 x 66.7 cm
Herzog Anton Ulrich-Museum, Brunswick

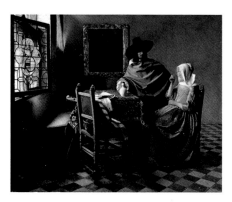

The Glass of Wine, c. 1658–60
Oil on canvas, 65 x 77 cm
Gemäldegalerie, Staatliche Museen,
Preußischer Kulturbesitz, Berlin
Page 26

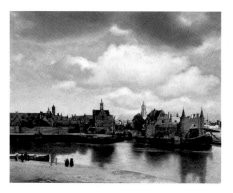

View of Delft, c. 1660–61
Oil on canvas, 96.5 x 115.7 cm
Royal Cabinet of Paintings
Mauritshuis, The Hague
Pages 42/43

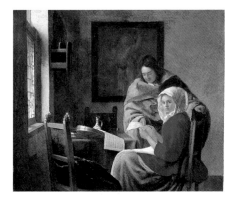

Girl Interrupted at her Music, c. 1660–61
Oil on canvas, 39.9 x 44.4 cm
The Frick Collection, New York

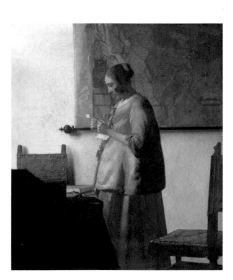

Woman in Blue Reading a Letter, c. 1663–64
Oil on canvas, 46.6 x 39.1 cm
Rijksmuseum, Amsterdam
Page 74

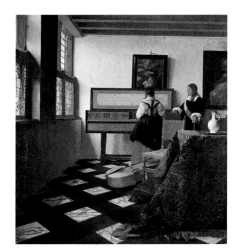

The Music Lesson, c. 1662–64
Oil on canvas, 74 x 64.5 cm
Her Majesty Queen Elizabeth II, The Royal
Collection, Windsor Castle
Page 16

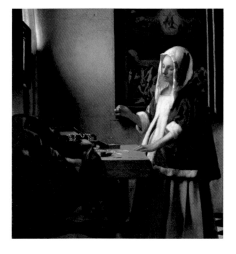

Woman Holding a Balance, c. 1664
Oil on canvas, 40.3 x 35.6 cm
The National Gallery of Art,
Washington D.C., Widener Collection
Page 17

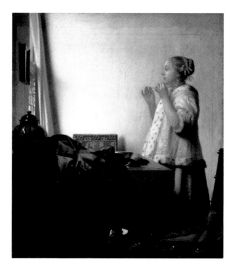

Woman with a Pearl Necklace, c. 1664
Oil on canvas, 51.2 x 45.1 cm
Gemäldegalerie, Staatliche Museen
Preußischer Kulturbesitz, Berlin
Page 77

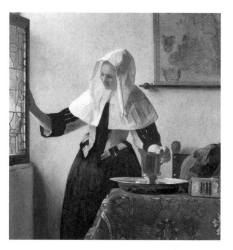

Woman with a Water Jug, c. 1664–65
Oil on canvas, 45.7 x 40.6 cm
The Metropolitan Museum of Art, New
York, Gift of Henry G. Marquand, 1889,
Marquand Collection
Page 30

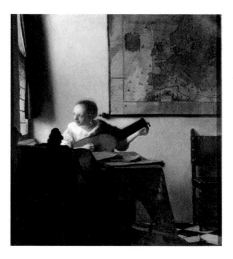

Woman with a Lute, c. 1664
Oil on canvas, 51.4 x 45.7 cm
The Metropolitan Museum of Art, New
York, Bequest of Collis P Huntington, 1900
Page 65

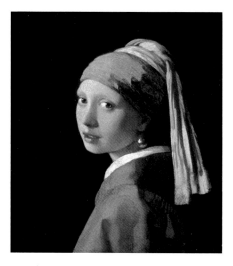

The Pearl Earring, c. 1665
Oil on canvas, 44.5 x 39 cm
Royal Cabinet of Paintings
Mauritshuis, The Hague
Page 6

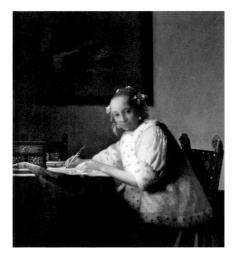

A Lady Writing, c. 1665
Oil on canvas, 45 x 39.9 cm
The National Gallery of Art, Washington
D.C., Gift of Harry Waldron Havemeyer
and Horace Havemeyer, Jr., in memory
of their father, Horace Havemeyer

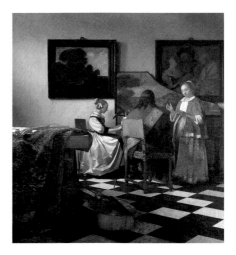

The Concert, c. 1665–66
Oil on canvas, 72.5 x 64.7 cm
Isabella Stewart Gardner Museum, Boston
Page 14

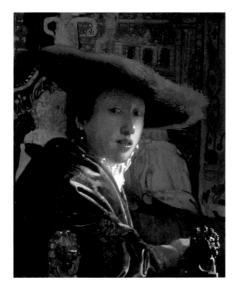

Girl with a Red Hat, c. 1665
Oil on panel, 22.8 x 18 cm
The National Gallery of Art, Washington
D.C., Andrew W. Mellon Collection
Page 33

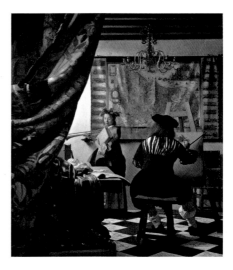

The Art of Painting, c. 1666–67
Oil on canvas, 120 x 100 cm
Kunsthistorisches Museum, Vienna
Page 36

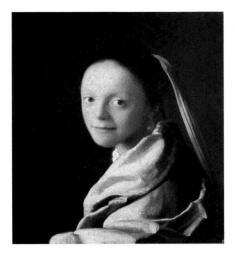

Portrait of a Young Woman, c. 1666–67
Oil on canvas, 44.5 x 40 cm
The Metropolitan Museum of Art,
New York, Gift of Mr. and Mrs. Charles
Wrightsman, in memory of Theodore
Rousseau, Jr., 1979

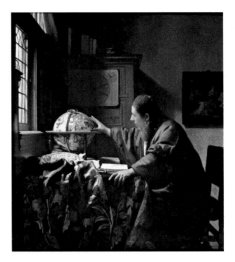

The Astronomer, 1668
Oil on canvas, 51.5 x 45.5 cm
Musée du Louvre, Paris
Page 70

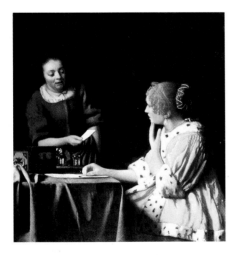

Mistress and Maid, c. 1667–68
Oil on canvas, 90.2 x 78.7 cm
The Frick Collection, New York

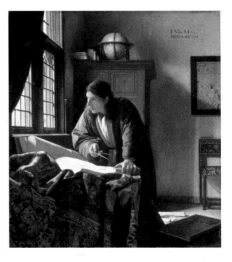

The Geographer, 1669
Oil on canvas, 51.6 x 45.4 cm
Städelsches Kunstinstitut,
Frankfurt am Main
Page 55

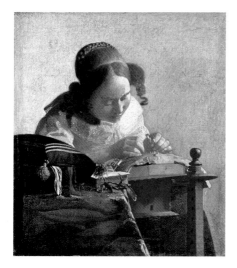

The Lacemaker, *c*. 1669–70
Oil on canvas on panel, 23.9 x 20.5 cm
Musée du Louvre, Paris
Page 27

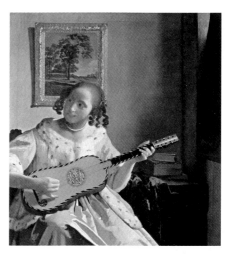

The Guitar Player, *c*. 1670
Oil on canvas, 53 x 46.3 cm
English Heritage as Trustees of the Iveagh
Bequest, Kenwood House, London

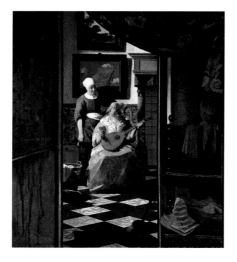

The Love Letter, *c*. 1669–70
Oil on canvas, 44 x 38 cm
Rijksmuseum, Amsterdam
Page 76

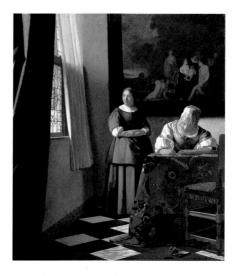

A Lady Writing a Letter with her Maid,
c. 1670
Oil on canvas, 72.2 x 59.7 cm
The National Gallery of Ireland, Dublin

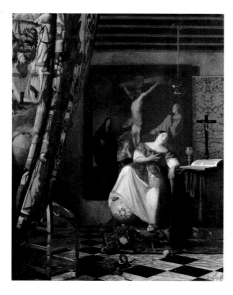

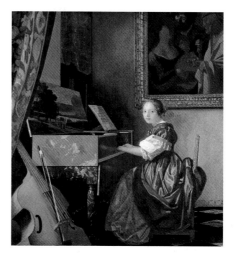

Allegory of Faith, c. 1671–74
Oil on canvas, 114.3 x 88.9 cm
The Metropolitan Museum of Art, New York,
The Friedsam Collection, Bequest of Michael
Friedsam, 1931
Page 11

A Lady Seated at the Virginal, c. 1675
Oil on canvas, 51.1 x 45.6 cm
The National Gallery, London
Page 15

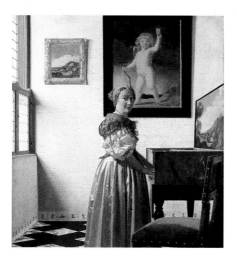

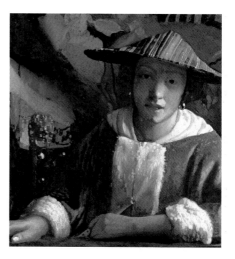

A Lady Standing at the Virginal, c. 1672–73
Oil on canvas, 51.8 x 45.2 cm
The National Gallery, London

Attributed to Vermeer:
A Young Woman with a Flute, 1665–70
Oil on panel, 20.3 x 17.8 cm
The National Gallery of Art, Washington
D.C., Wiedener Collection

The Little Street, detail

BIOGRAPHY

1632

Johannes Vermeer is the second child born to Reynier Jansz. Vos and Digna Baltens in Delft and is baptized in the town's New Church. His father is a silk weaver who produces a particularly fine material called caffa. He also runs an inn in Delft's Volgersgracht and in 1631 is registered as an art dealer in Delft's Guild of St Luke.

1641

Vermeer's father buys a house and the adjacent sixteenth-century Mechelen Inn on Delft's main square. He continues to trade successfully as an art dealer from these premises.

1652

Vermeer's father dies and Johannes takes over the inn and the art business.

1653

Vermeer marries Catharina Bolnes (*b*. 1631), the daughter of Maria Thins and Reynier Bolnes, who lived apart from 1641. The marriage ceremony is held in Schipluiden, about an hour's walk from Delft. Maria Thins is from a wealthy, Catholic patrician family. A moneyed mother-in-law with a strong personality, she plays an important role in Vermeer's family life. It is probably due to her influence that Vermeer converted to Catholicism shortly before his marriage. Vermeer is registered as an artist in Delft's Guild of St Luke.

1660

Vermeer, his wife and three children move into a house on 'Oude Langendijk' that they will later share with Maria Thins.

1662

Vermeer is elected head of Guild of St Luke. He is visited by the French diplomat Balthasar de Monconys.

1669

Pieter Teding van Berckhout, a well-known burgess of The Hague, visits Vermeer's studio and praises the artist's paintings for their "unusal and quite unique perspective". This visit shows that Vermeer was already recognised as an artist beyond the confines of Delft.

1670

Vermeer's mother dies; shortly after, his elder sister, and only sibling, also dies. Both are buried in Delft's New Church.

1671

Vermeer is again called upon to act as head of Delft's Guild of St Luke.

1672

Along with the Delft artist Johannes Jordaens (1616–80), Vermeer is summoned to The Hague as an expert witness to give an appraisal of twelve Italian paintings. Later in the year, Vermeer experiences great financial difficulties because of the dire economic situation following the French invasion under King Louis XIV; he lets out the inn.

1674

Vermeer's father-in-law Reynier Bolnes dies and Vermeer travels to Gouda to settle his estate.

1675

Vermeer dies aged 43 and is buried in the family grave in Delft's Old Church. He leaves eleven children and debts that will cause his wife great financial suffering long after his death.

SELECTED BIBLIOGRAPHY

Aillaud, Gilles, Albert Blankert and John Michael Montias. *Vermeer*, Geneva 1987

Alpers, Svetlana. *Die Kunst als Beschreibung. Holländische Malerei des 17. Jahrhunderts*, Cologne 1985

Arasse, Daniel. *Vermeer's Ambition*, Dresden 1996

Ibid. *Vermeer, Faith in Painting*, Princeton 1994

Blankert, Albert. *Vermeer van Delft*, Oxford 1978

Gaskell, Ivan and Michiel Jonker (eds.). *Vermeer Studies* (Studies in the History of Art, 55, Symposium Papers XXXI-II, Center for Advanced Studies, National Gallery of Art, Washington) New Haven, London 1998

Haks, Donald and Marie Christine van der Sman (eds.). *Dutch Society in the Age of Vermeer* (exhib. cat., The Hague Historical Museum), Zwolle 1996

Hedinger, Bärbel. *Karten in Bildern. Zur Ikonographie der Wandkarte in holländischen Interieurgemälden des 17. Jahrhunderts*, Hildesheim 1986

Hertel, Christiane. *Vermeer. Reception and Interpretation*, Cambridge 1996

Kaldenbach, Kees. 'Ein Flug über die *View of Delft*. Jan Vermeer's Meisterwerk von 1660 als virtuelle Welt,' in: *Weltkunst*, no. 2, Feb. 1999, pp. 308–310

Kersten, Michiel C. C. and Daniëlle H. A. Lokin (eds.). *Delft Masters, Vermeer's Contemporaries* (exhib. cat. Stedelijk Museum Het Prinsenhof, Delft), Zwolle 1996

Kühn, Hermann. 'A study of the pigments and the grounds used by Vermeer,' in: *Reports and Studies in the History of Art*, II, Washington 1968, pp. 155–202

Liedtke, Walter (ed.), *Vermeer and the Delft School* (exhib. cat., The Metropolitan Museum of Art, New York) New Haven, London 2001

Maek-Gérard, Michael (ed.). *Johannes Vermeer. Der Geograph, der Astronom nach 200 Jahren wieder vereint*, Ostfildern 1997

Montias, John Michael. *Vermeer and his Milieu – A Web of Social History*, Princeton 1989

Netta, Irene. *Das Phänomen Zeit bei Jan Vermeer van Delft*, Hildesheim 1996

North, Michael. *Kunst und Kommerz im goldenen Zeitalter. Zur Sozialgeschichte der niederländischen Malerei des 17. Jahrhunderts*, Cologne 1992

Pops, Martin. *Vermeer. Consciousness and the Chamber of Being*, Michigan 1986

Schama, Simon. *The Embarrassment of Riches. An Interpretation of Dutch Culture in the Golden Age*, New York, 1987

Schlenke, Hubertus. *Vermeer mit Spinoza gesehen*, Berlin 1998

Schwarz, Heinrich. 'Vermeer and the Camera Obscura,' in: *Pantheon* XXIV, 1966, pp. 170–180

Seymour, Charles Jr. 'Dark chamber and light-filled room: Vermeer and the Camera Obscura,' in: *The Art Bulletin* XLVI, 1964, pp. 323–331

Snow, Edward. *A study of Vermeer*, Berkerly, Los Angeles, London 1979

Swillens, P. T. A. *Johannes Vermeer. Painter of Delft*, Utrecht, Brussels 1950

Thoré, Théophile. 'Van der Meer de Delft,' in: *Gazette des Beaux-Arts* 21 (1866), pp. 297–330

Wadum, Jorgen. *Vermeer illuminated. Conservation, Restauration and Research*, The Hague 1994

Ibid. 'Vermeer's Use of Perspective,' in: *Historic Painting Techniques, Materials and Studio Practice. Reprint of a Symposium held at the University of Leiden*, Santa Monica 1995, pp. 148–154

Walsh, John and Hubert von Sonnenburg. 'Vermeer,' in: *The Metropolitan Museum of Art Bulletin* 31, Nr. 4, 1973

Weber, Gregor, J. M., '*Caritas Romana*. A newly discovered painting by Johannes Vermeer', in Weltkunst, issue 2, Feb. 2000, pp. 225–28

Welu, James A. 'Vermeer: His Cartographic Sources,' in: *The Art Bulletin* 57, 1975, pp. 529–547

Ibid. *Vermeer and Cartography*, Ann Arbor, Michigan 1981

Wheelock, Artur K. Jr. *Perspective, Optics and Delft Artists around 1650*, New York 1977

Ibid. 'Vermeer's Painting Technique,' in: *Art Journal*, Summer 1981, pp. 162–164

Ibid. 'Pentimenti in Vermeer's Paintings: Changes in Style and Meaning,' in: *Holländische Genremalerei im 17. Jahrhundert, Symposium 1984, Jahrbuch Preußischer Kulturbesitz*, H. Bock and Th. Gaethgens (eds.), vol. 4, Berlin 1987, pp. 385–412
Ibid. *Jan Vermeer*, London 1981 (English) and 1988 (German)

Ibid. *Vermeer & the Art of Painting*, New Haven, London 1995

Ibid. (ed.), *Vermeer. Das Gesamtwerk*, Stuttgart 1995

Ibid. (ed.), *The Public and the Private in the Age of Vermeer* (exhib. cat., Hata Foundation and Osaka Museum of Art, London 2000

Ibid, and Kees Kaldenbach
Vermeer's 'View of Delft' and his vision of realtity, in: *Artibus et Historiæ* 3, Nr. 6 (1982), pp 9–35

COMPARATIVE ILLUSTRATIONS

p. 54
Detail from the *View of Delft*, see p. 42f. and p. 83

p. 56
Petrus Kaerius Caelator
Map of Holland, 1596
Algemeen Rijksarchief, The Hague

p. 57
Claes Jansz. Visscher
Equestrian Portrait of William of Orange, detail from the
Map of the Seventeen Provinces, 1636
Slott Skokloster, Uppsala

p. 59
Claes Jansz. Visscher
The Binnenhof in The Hague
Detail from the *Map of the Seventeen Provinces*, 1636
Slott Skokloster, Uppsala

p. 60
Dirck van Delen
The Tomb of William I of Orange, 1645
Rijksmuseum, Amsterdam

p. 63 (top)
Pieter de Hooch
A Woman and her Maid in a Courtyard, c. 1660
The National Gallery, London

p. 63 (bottom)
Pieter Jannsens Elinga
Room in a Dutch House
The Hermitage, St. Petersburg

p. 66
Unknown artist
*Market Square at Delft showing the Town Hall and the New
Church*, 1765
Stedelijk Museum Het Prinsenhof, Delft

p. 67
Abraham Rademaker
The Mechelen Inn (detail from *Gesicht op de Markt*), c. 1720
Gemeentelijke Archiefdienst Delft

S. 68
Abraham Rademaker
The Jesuit Church in Delft, c. 1720
Gemeentelijke Archiefdienst Delft

Unless otherwise noted, the picture material was provided
by the respective museums or taken from the Publisher's
own archives.

AKG Berlin: p. 36, p. 86 bottom right

Artothek: pp. 65, 76, 85 bottom left, 86 top left, 88 bottom
left; 32, 81 bottom left (photos: Joachim Blauel); 55, 87
bottom right (photos: Blauel/Gnamm); 30, 85 top right
(photos: Joseph S. Martin); 70, 87 (photos: Peter Willi)

© Bildarchiv Preußischer Kulturbesitz, Berlin, 2001: pp.
26, 77, 83 bottom left, 85 top left (photos: Jörg P. Anders)

The Bridgeman Art Library, London/Paris/New York:
pp. 14, 86 top right

Carafelli, Richard (photos): pp. 33, 86 bottom left

Estel/Klut, Dresden (photos): pp. 12, 29, 81 bottom right,
82 bottom left

Grove, Bob (photos): p. 89 bottom right

Museumsfoto Bernd-Peter Keiser: p. 83 top right

RMN – R.G. Ojeda: pp. 27, 88 top left

Front cover: *The Pearl Earring* (see p. 6)
Spine: detail from *The Pearl Earring*
Frontispiece: *The Little Street*
Back cover: *The Art of Painting* (see p. 36)

The Library of Congress Cataloguing-in-Publication
data is available;
British Library Cataloguing-in-Publication Data:
a catalogue record for this book is available from the British Library;
The Deutsche Bibliothek holds a record of this publication
in the Deutsche Nationalbibliografie; detailed bibliographical
data can be found under: http://dnb.ddb.de

© Prestel Verlag, Munich · Berlin · London · New York 2004
(first published in hardback in 1997)

Prestel Verlag
Königinstrasse 9 · 80539 Munich
Tel. +49 (89) 38 17 09-0
Fax +49 (89) 38 17 09-35

Prestel Publishing Ltd.
4 Bloomsbury Place, London WC1A 2QA
Tel. +44 (020) 7323-5004
Fax +44 (020) 7636-8004

Prestel Publishing
900 Broadway, Suite 603, New York, NY 10003
Tel. +1 (212) 995-2720
Fax +1 (212) 995-2733

www.prestel.com

Prestel books are available worldwide. Please contact your
nearest bookseller or one of the Prestel offices listed above
for details concerning your local distributor.

Translated from the German by Stephen Telfer, Edinburgh
Edited by Christopher Wynne

Designed by Meike Weber
Lithography: Eurocrom 4, Villorba, Italy
Cover designed by Matthias Hauer
Printed by Passavia Druckservice, Passau
Bound by Conzella, Pfarrkirchen

Printed in Germany on acid-free paper

ISBN 3-7913-3080-2 (flexi-cover)